VIVIENNE WESTWOOD
A London Fashion

This book has been published
to coincide with the exhibition
*Vivienne Westwood: the
collection of Romilly McAlpine*

VIVIENNE WESTWOOD

A London Fashion

MUSEUM OF LONDON

Philip Wilson Publishers

Acknowledgements

We are grateful to Romilly McAlpine, whose collection was the starting point for this book. Her contributions to the section 'Collecting Westwood' have been greatly appreciated.

We are also grateful to Catherine McDermott for curating the exhibition *Vivienne Westwood: the collection of Romilly McAlpine* and for her valuable contribution to this publication.

The majority of the statements in the section 'Wearing Westwood', and those of the two 'makers', were derived from interviews by Oriole Cullen, Catherine McDermott and Azusa Ozawa. We are grateful to them and to the wearers and makers themselves for their time and efforts.

The authors would also like to thank the following for their help and advice: Katherine Baird and staff at the London College of Fashion Library; Clare Browne and Claire Wilcox at the Victoria & Albert Museum; Derek Dunbar and Simon Barker; Tara Gibson and Mary Aitken at Lochcarron of Scotland; Kevin Graham; Sharee Gum; Julia Murray and Jo Charlton at the Wallace Collection; Julia Newcomb; Barbara Owen; Vivienne Westwood Ltd; Robert Woodvine; and Penelope Woolfit.

First published in 2000 by
Philip Wilson Publishers Ltd
143–149 Great Portland Street
London W1N 5FB

Distributed in the USA and Canada by
Antique Collectors' Club
91 Market Street Industrial Park
Wappingers' Falls
New York 12590

ISBN 0-85667-525-3 (cloth)
ISBN 0-904818-96-9 (paper)

Written, designed and photographed by the Museum of London
Photographers: John Chase, Torla Evans and Richard Stroud
Designer: Kirsten Laqua
Editor: Mark Kilfoyle
Additional research: Oriole Cullen, Edwina Ehrman and Stephen Green

Cover
Romilly McAlpine wearing a 1993 *Anglomania* Arresting skirt and a pair of Rocking Horse boots, a Westwood classic

Back cover
Yoshii Ohta-Jones wearing a 1998 *Gold Label* skirt and shoes from the Spring collection

Contents

Foreword

Vivienne Westwood is widely acknowledged not only as one of Britain's most important fashion designers but as one of the most influential designers in the world. She was the first to bring British street-style to the catwalk and paved the way for the next generation of British designers. Her avant-garde designs have had a lasting influence on her peers.

Vivienne Westwood's career has been based in London, at the heart of the British fashion industry. Her work reflects the city's edgy creativity and the energy generated by its innovative designers, artists and musicians. Londoners who wear Westwood's clothes are seen here quite literally 'in the frame' of some of London's most evocative and inspiring locations. The book has been published to accompany the Museum of London's exhibition *Vivienne Westwood: the collection of Romilly McAlpine*, the first major British exhibition to celebrate this world-class talent.

Vivienne Westwood was honoured with an OBE in 1992 and her company, Vivienne Westwood Ltd, awarded the Queen's Award for Export in 1998 in recognition of her increasing international profile. Yet Westwood's Englishness is her strength: her respect for traditional British tailoring and dressmaking techniques, her love of traditional British fabrics and her debt to the past. Working within and in opposition to tradition, her clothes are invariably thought-provoking and inspirational.

The dialogue between designer and wearer turns art into fashion, costume into clothes. As Westwood herself illustrates time and again, wearing her clothes is the point, as Romilly McAlpine and the wide array of Londoners we interviewed agree. We are grateful to Romilly McAlpine for allowing us to display her collection of Westwood clothes and for making this celebration of Vivienne Westwood's work possible.

Simon Thurley
Director

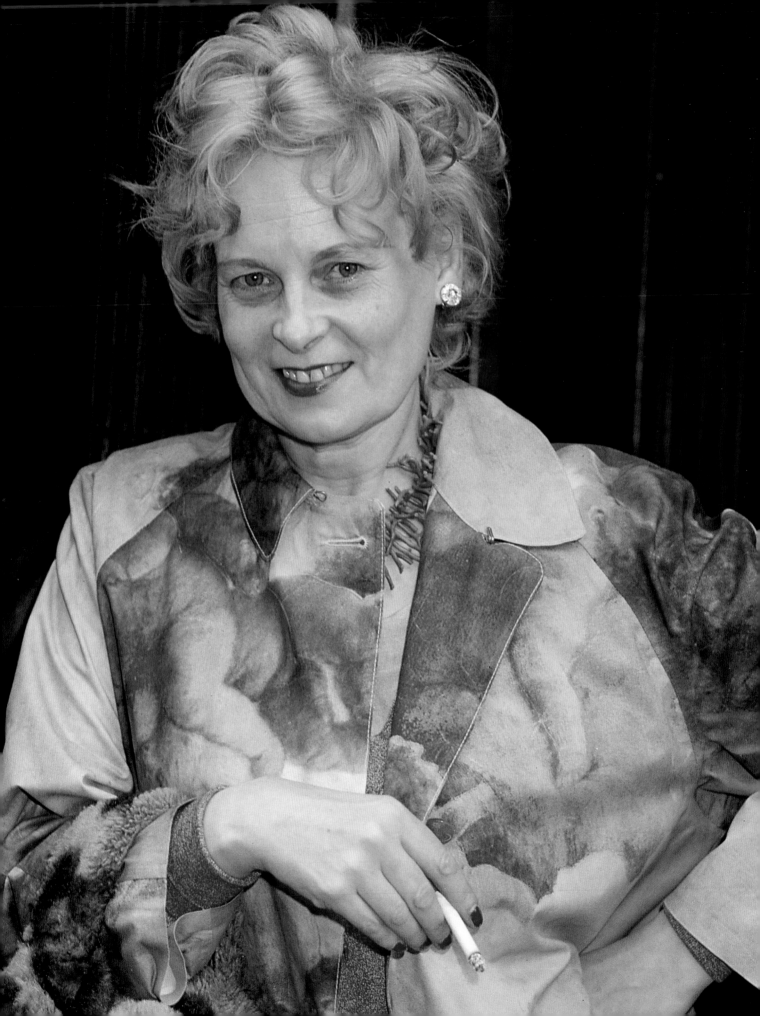

Introduction

A wearable fashion

Catherine McDermott

For nearly three decades, Vivienne Westwood has remained central to certain ideas about creativity in Britain – its original take on culture, its sense of the edge, its stories and narrative themes. Westwood has come to represent London fashion, at least of the kind the world is interested in. She was born in Derbyshire, moved to Harrow in the 1950s and has lived in London ever since, having settled for the past thirty years in Clapham in South London. Her fashion shows may be staged in Paris, but if you want to buy Vivienne Westwood at source, you really have to come to London: to World's End on the King's Road, where she has had a shop since 1971; to the more upmarket Davies Street shop off Bond Street; and to Conduit Street, where her trailblazing shop has attracted a chic circle of fashion retailers. Quite simply, Vivienne Westwood has become one of the world's fashion superstars. To celebrate her success, the Museum of London is staging London's first exhibition dedicated solely to Westwood's work.

The display has been chosen from the collection of Romilly McAlpine. Romilly McAlpine began buying Westwood around 1986, at a crucial moment in the designer's career. Vivienne Westwood's involvement in the radical world of punk culture had reshaped the creative direction of a whole generation. During the 1980s, if you were interested in the cutting edge of fashion, you looked at what young people in London were wearing. By 1990, however, young people no longer enjoyed quite the same power and Westwood began to move in a different direction. She had, in effect, finished one career and started another. The clothes from the McAlpine collection illustrate Westwood's new vision in a series of original pieces of day and evening wear.

It took a long time, however, for the media to allow her to shake off the legacy of punk. Westwood was seen as a perverse but typically British talent, interesting but unwearable and hopelessly uncommercial. Her breakthrough came in 1989 when her name appeared in a list by John Fairchild, the American publisher of *Women's Wear Daily*, of the top six designers in the world. 'There are six designers today who are true twinkling stars: Yves Saint Laurent, Giorgio Armani, Emmanuel Ungaro, Karl Lagerfeld, Christian Lacroix and Vivienne Westwood. From them, all fashion hangs by a golden thread. If the thread breaks, if they make a mistake, billions of dollars may be lost. All eyes are on these six: they show the rest of the industry where to go'.[1]

But if the media were slow to recognise Westwood's new agenda, others were not. In the 1990s, Romilly McAlpine became one of Westwood's most important clients. She was, Vivienne Westwood said, one of two people who looked best in her clothes. This book and the Museum of London exhibition document the importance of this relationship between wearer and designer.

They make an interesting contrast of personalities. Vivienne Isabel Swire was the daughter of Gordon Swire, a munitions worker, and Dora, a textile weaver who later ran the village sub-post office in Tintwistle, near Manchester. Romilly Hobbs was born in Shanghai, the daughter of banker Tim Hobbs and his wife Joyce. She spent her early childhood travelling and living in the Middle and Far East. After spending much of her early twenties in Europe, she settled in London and was proprietor of the well-known grocer's Hobbs & Co. until 1989. As the wife of Lord McAlpine, treasurer of the Conservative Party from 1975–90, she found herself at the centre of British political life. Vivienne Westwood would not perhaps have been the first and most obvious choice to dress such a woman. Romilly McAlpine wore Westwood clothes to many state occasions: the Opening of Parliament, to Buckingham Palace and various official dinners at No. 10 Downing Street given for visiting Heads of State, as well as to more informal gatherings such as Cabinet Ministers' dinner and cocktail parties. She recalls that Margaret Thatcher would often comment on the clothes, showing particular interest in their details – the buttons and fastenings – and the fabrics. Her Westwood collection is a fascinating insight into late twentieth-century taste and public life.

Romilly McAlpine has pursued a passionate interest in fashion all her life. She not only collects work by Vivienne Westwood, but also the work of other designers, including Rudy Gernreich, Liza Bruce, Romeo Gigli, Azzedine Alaïa and Jean-Paul Gaultier. Her collection, including vintage items, contains more than 1,500 pieces. She collects to wear, but also because she considers twentieth-century fashion to be a new art form.

It was through a series of dramatic evening wear collections that Westwood reinforced her reputation as a continuing force in the nineties. Her dresses and accessories used a series of almost childlike quotations from the European past: corsets and bustles, gilt frames, *commedia dell'arte* costumes, paintings by Fragonard and earlier artists of the French rococo. Her research, by her own admission, is in the great museums of London, since for Westwood, history is a way of reappraising the erotic. Her fixation on historical details represents what Westwood has memorably called 'a charge of content'.[2]

Technically Westwood was self-taught. Her only formal education was a term at Harrow College of Art as a silversmith, followed by secretarial school and training as a primary school teacher. She doesn't work with conventional toiles, but cuts and pins fabric to a lay figure. In this way, Westwood focuses on the strength and sexuality of the body. The visual references are, of course, quite different. If the evening wear explores the world of the Wallace Collection, the day wear reappraises more broadly British culture as a whole. Within this context, Westwood's fixation with British uniforms (always a rich area for erotic fetishism) is telling. England is full of uniforms, from the Queen's familiar attire to shooting jackets, scarlet fox-hunting coats and pinstripes for city gents. Westwood's use of fabrics such as Harris Tweed from the Hebrides and Scottish tartan weaves harks back to a past of country life and natural environments while at the same time exploiting the frisson of cross-dressing through Westwood's particular London style.

This book does not simply show the work of a single, important collector. It documents a range of people who wear Westwood in London: men and women, old and young, students, clubbers, shop assistants, socialites and business women. Each of the

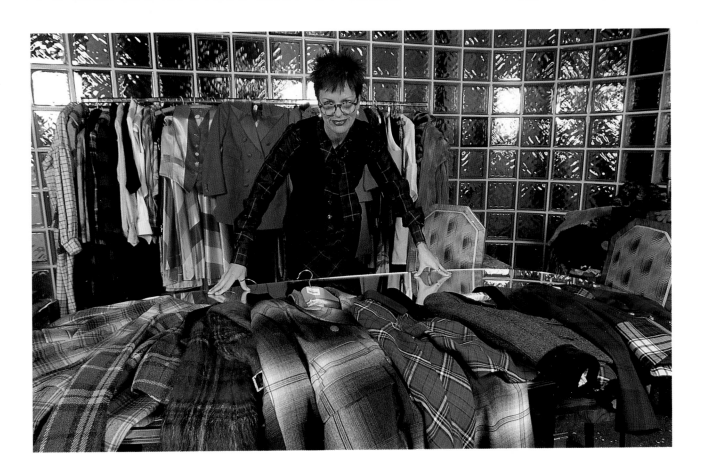

twenty-two individuals we include chose their own Westwood outfit and a London
location in which to be photographed. Similar themes emerge from their comments.
They find that the construction of the clothes reveals the exploratory edge in
Westwood's designs that makes her work sexy and appealing. Without exception, the
women mention their pleasure in the defining femininity of the cut and all the wearers
admire the highly individual male and female silhouettes Westwood creates. For these
Londoners, the clothes are wearable, sexy and desirable for a variety of functions,
whether it's Amanda Lucas's wedding dress, Tiger Savage's power-dressing in the male-
dominated world of advertising or Cecilia Fage's classic twinset as workwear. Westwood's
appeal can and does cross age and gender barriers. The painter Patrick Hughes buys
classic suits, Rod Taite bought his jacket second-hand, while David Hart goes for the
clubbing image.

The concluding section is entitled 'Making Westwood'. Almost everything that has been
written about Vivienne Westwood focuses on her personality. The Museum of London's
celebration of this great London designer concentrates on her clothes: on Westwood's
genius for cut and construction, her tailoring, and her sensitive and witty manipulation
of traditional fabrics. The essay, 'Cut and Construction', looks in detail at four of the
garments included in the exhibition, drawing attention to Westwood's skills as a
designer of clothes that her customers love to wear. The book closes with two
interviews with the makers themselves, those who turn the Westwood vision into reality.

It has become impossible to visualise the last three decades of London style without
the essential dynamic of Vivienne Westwood. Her clothes have helped define the key
themes of late twentieth-century fashion. She has changed the relationship of clothes
to the body and offered men and women, whether or not they bought her clothes,
choices they had never enjoyed before.

Collecting
Westwood

'I do believe that my clothes are a
criticism of mediocrity and orthodoxy'.

Vivienne Westwood, 1995

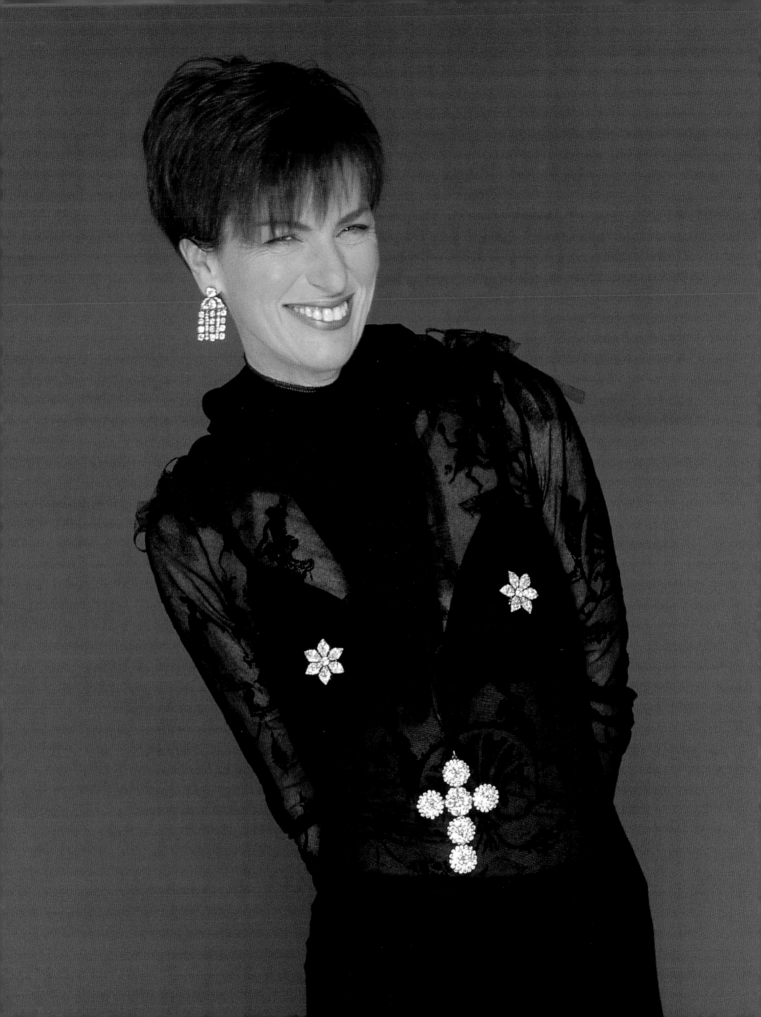

Romilly McAlpine

In conversation with Moira Gemmill

Former contributing editor to English Vogue *and to American* Harper's Bazaar, *Romilly McAlpine has been interested in fashion and design from an early age. She collects work by several fashion designers, but has a particularly interesting and diverse collection of clothes by Vivienne Westwood. She is married to Lord McAlpine (former treasurer of the Conservative Party), who is also a keen collector and writer. She now lives in Europe with husband Alistair and daughter Skye.*

MG: When did you first start to acquire Vivienne Westwood clothes?
RM: I must have first gone to the shop in Davies Street in London around 1985 or 1986, on the advice of Liza Bruce and Nicholas Barker, the designers. I was always drawn to fashion as art and to the avant-garde. They are very talented designers themselves, and so if they say that someone else is interesting and important, you go and have a look. And as soon as I walked in, I thought, 'What fun! And how wacky it is!'

MG: What was it like?
RM: The shop was long and narrow with a dark uneven wooden floor. Initially, it had no decorative features whatsoever. Just the clothes and an open fireplace with a real fire in winter – most unusual for a London fashion establishment. At the end of the shop was a glass counter filled with

Vivienne's jewellery and a staircase leading downstairs. The changing rooms were a curtained-off area which doubled on occasion as storage, so customers often had to change in the middle of the basement area. It was only later that the shop became much smarter.

My overriding memory is of absolute chaos! If you pulled out an outfit or a skirt and asked, 'Have you got this in a smaller size?' they wouldn't know *(laughs)*. But it was a lot of fun and a very intimate atmosphere as well. Vivienne's always been able to make things very intimate.

And of course the staff made all the difference: Derek Dunbar, Amanda Hart, Jibby Beane. They were wonderful. It was more like a social occasion than a business transaction. It was always amusing to go in, as long as you had a bit of time and weren't in a rush.

Left
Romilly McAlpine wearing a Boulle tulle dress, flock print on stretch cotton tulle, *Salon*, Spring/Summer 1992

MG: How did your interest in fashion come about?

RM: I've always loved clothes and I have a husband who has encouraged me, which helps, because so many, particularly English, men don't! So I was lucky there. Also, Vivienne wasn't that expensive at that time, not compared to designers like Giorgio Armani or Gianni Versace.

MG: And so you started to buy.

RM: Yes, I bought a few of the clothes and found them surprisingly wearable. The first things I remember buying were Scottish tweeds, a turquoise riding jacket, some really, really short skirts, and a lovely orange and black outfit.[1] Then I bought a rough tartan tweed in oranges with a short bell skirt and jacket.[2] I remember wearing that with boots and dark tights, and people saying to me, 'Gosh, that looks amazing. What is it? Where does it come from?' Vivienne was always so interesting that way. It was, in some respects, just a short skirt. But there was always some twist to it, something special that drew people's notice.

MG: And did you buy them for specific occasions?

RM: Sometimes. I bought some for weddings. Some I just bought for sheer pleasure, and though with one or two I haven't actually been able to find the right occasion to wear them, they're still wonderful and *I know they're there!* But some, like the early Harris tweeds, were just day wear, just fun wear. I was experimenting really.

MG: So from the late eighties, you became a regular customer.

RM: Yes, though elsewhere as well. I was collecting clothes by Azzedine Alaïa, Romeo Gigli, Donna Karan, Ossie Clark, Thea Porter, Rudy Gernreich. But she was the one I rated most at that time. And she got better as well.

MG: In what respect?

RM: Her tailoring improved, the clothes fitted better. What is so amazing about Vivienne is how intricate some of her designs are. They are very complicated pieces, works of art really.

MG: And yet you have to look at them closely to realise that.

RM: Yes, and you probably have to get into them even to realise how they are constructed around your body. Which she does in an amazing way. I often used to think it was because she was a woman in what was then a world of mainly male designers. But look at Donna Karan – they aren't really constructed around the body in the same way. Maybe it's just Vivienne.

MG: And do you think her approach to the female body influenced other designers?

RM: I think so. In the early nineties, I remember being in Paris and going to a lot of shows then because I was working for *Vogue* and meeting designers such as Karl Lagerfeld and Azzedine Alaïa. They all said the one they watched was Vivienne. I remember lunching at Harry's Bar in London one day with Karl and Liz Tilberis, then editor of English *Vogue*, and Karl asked me who I was collecting and wearing at the time. 'Vivienne Westwood', I replied, and he said, 'How wise' and that he knew her work well and how highly he regarded her.

MG: For what reasons?

RM: Because she was always fresh and innovative. She was the first one to bring in bustiers, for instance. I remember when I first wore those bustiers. They gave you an incredible shape. People would gawk, you know. They didn't know *why* the bustier was shocking – because it didn't reveal any more than the clothes they were wearing – but somehow it was shocking. But then, two years later, everybody was wearing bustiers. There was

Right
Romilly McAlpine wearing a Dunbar jacket, Bow blouse and Arresting skirt made up in Pink Gordon tartan, *Anglomania*, Autumn/Winter 1993

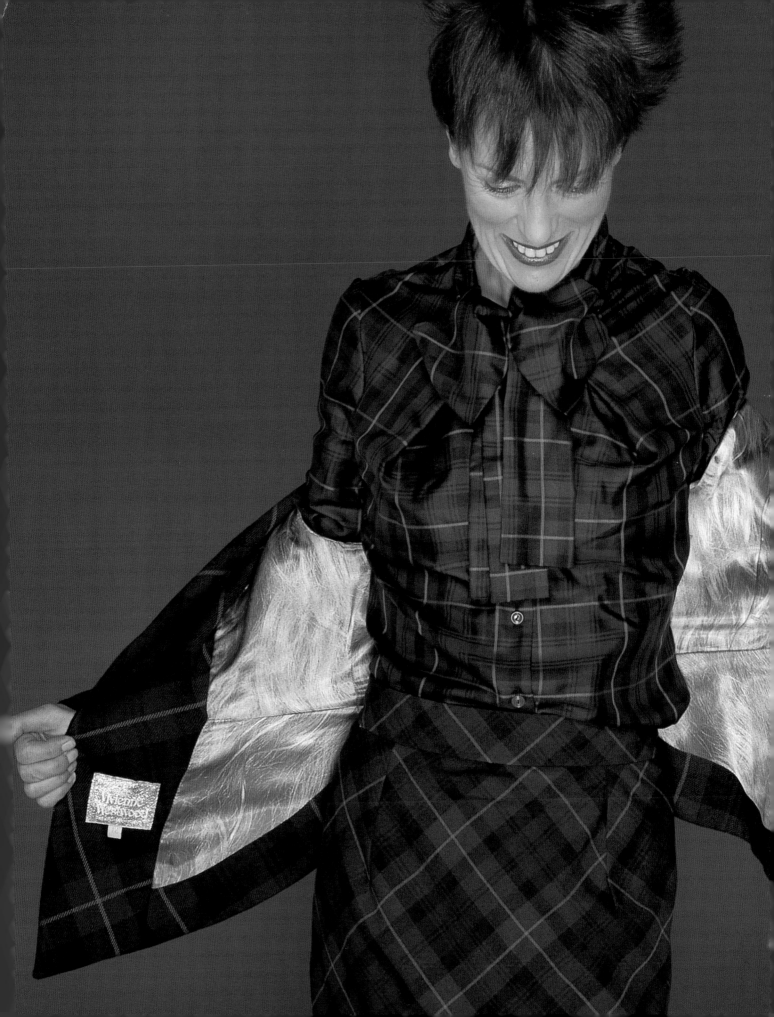

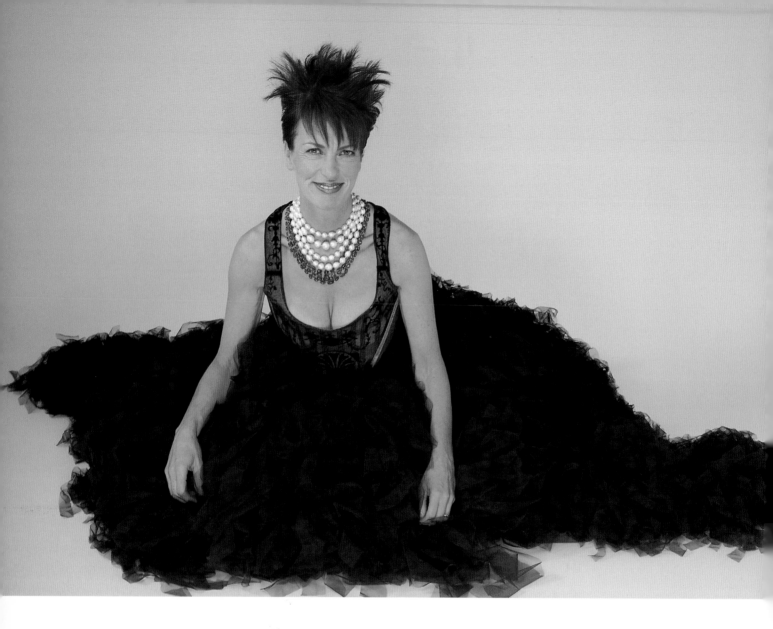

always something witty about Vivienne. Her shoes, her bags, the actual dresses themselves – they were always cocking the snook. Other people were doing safer versions, but Vivienne always added the final twist, always went one step further. And everything she did was just that little bit more feminine. I felt very feminine wearing Vivienne's clothes because they were always made to fit your body so well.

MG: It's evident from your collection that you admire very different types of Westwood design. Do you have a favourite Vivienne Westwood outfit?
RM: I love her black lace evening wear. And I love the bustiers. They give you the

most amazing shape. They're so beautifully finished, with the bones and the stays, and so tailored to your figure. Nobody else pays such close attention to detail and takes the time to do it.

I remember the first time I tried them on, thinking, 'Gosh, it's going to be uncomfortable with all those bones', but it wasn't. You don't want to put on any weight though!

MG: And does it make you think about your posture?
RM: Of course. You have to sit up straight, because there's nothing worse than a bit of flesh coming out between the stays *(laughing)*. Nothing worse.

Above
Romilly McAlpine wearing a shredded tulle skirt with a flock print Boulle tulle corset, *Salon*, Spring/Summer 1994

MG: And what draws you to Westwood? Is it the patterns? The quality of the material?

RM: Both. I love the mixing and matching. And I love her collars. She always makes your neck and your head stand up as if a plant or something exotic is emerging from the clothes. And they're never too tight. With so many designers, it looks interesting, but it's too tight or it's this or it's that. Vivienne's clothes, though you might not guess from looking at them, are wonderful not simply to look at, but to *wear*.

MG: *Did you have that sense when you were buying them? That they were things you wanted to wear?*

RM: Oh, yes. And the girls in the shop were walking adverts for the clothes. I'll never forget Amanda running across the wooden floor of the Davies Street shop one day in her high platform shoes and a short skirt with a bunny pompom on the back. She looked, with her racing long legs, so gorgeous. And made you realise how wearable the clothes are. The shoes, too. Yesterday, for instance, I was wearing the Rocking Horse shoes. Perfectly walkable and very comfortable. The only thing is: they make such a noise when you walk. I always feel that to be feminine you've got to be silent *(laughs)*. Not easy in those shoes.

MG: *But you have quite a collection of the very extreme platform shoes.*

RM: I bought those more as artwork and they eventually found a home on the mantelpiece in the sitting room of my house in Venice. I never wore them. I'm always far too frightened I'll break my ankle to wear them! Everyone assures me you can, though even Naomi Campbell, a practised walker in high heels, fell on the catwalk that time from a pair of Vivienne's platforms. But Vivienne herself wears them. I've even seen her on a bicycle in them!

MG: *What about the clothes in the Museum of London exhibition? The green tweed suit with the jewel insert, for instance?*

RM: I got that in the early 1990s. I remember wearing it to Christmas one year in Venice, because it's sort of Christmassy and you felt a bit like a fairy on top of a Christmas tree! Though when you look at it, the actual tailoring is absolutely classic: a long straight skirt and a riding jacket with a velvet collar at the back.[3] Vivienne can take a classical design and bring it up-to-date, turn it into something tongue-in-cheek. Was I about to go riding? Hardly! But she made a conventional jacket irreverent and thoroughly modern. It's that mix of tradition but with a twist, such as the inset jewels or whatever, that keeps it from seeming boring. But very classical, in some respects.

MG: *And the mackintosh?*

RM: The cherub mac.[4] People loved that. One morning I was walking down Madison Avenue and I decided to count how many people approached me in the street and it was seventeen! They said 'Gosh, where did you get it?' or remarked how beautiful it was, or how original. Seventeen times! And yet it was a completely classic cut. Just a rubberised riding mac with a cape

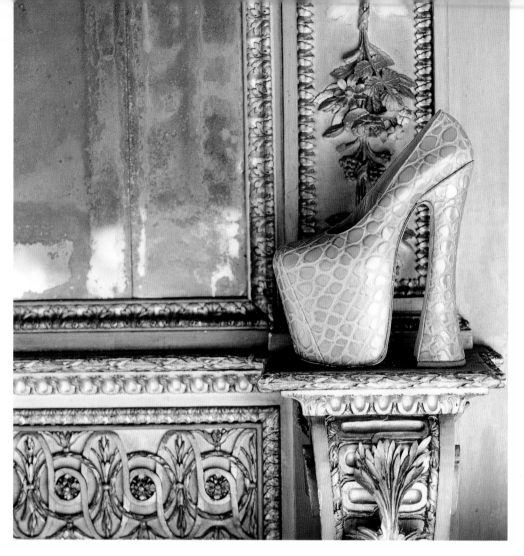

Left
Super elevated court shoe,
Grand Hotel, Spring/Summer
1993, adorning Romilly
McAlpine's mantelpiece

and a place to put your arms through. Another outfit I wore has the extra-ordinary feature that if you pull up the drawstrings through your legs, it shows your bum.[5] I loved that so much that I asked her to make two further ones for me in different fabrics, which she did. It was such an original idea. That was the year before she did the bum bags, so she was developing the idea of the bum. The outfit's so feminine, with its tight, high-waisted jacket with a little peplum. I think it's so sexy.

MG: Do you think that's part of an identifiable Westwood style? Can people tell you're wearing Westwood?
RM: Yes. It's the construction that's so different. Vivienne's things are very complicated, however simple they look.

That's why they've never been mass-produced. You couldn't do that sort of detail. And she's always taken so much trouble with the fabrics. There's one suit where the jacket has huge checks, but the trousers have straight lines.[6] And yet it all goes together. I don't know any other designer who has bothered to do that sort of thing.

MG: When, do you think, did you become a client rather than a customer?
RM: I think that probably developed by being there so much. You form a personal relationship with the people in the shop. Derek would ring me up and say, 'Listen, we've got the new collection in and I've put a couple of things aside for you'. And so it developed. I would go to the shows and see things and ring up Derek and say,

'Hey, I think that would be great for me'. Then Vivienne, knowing that I was interested, would send me messages. We would send notes to one another, things like that. Vivienne seemed to know instinctively what would suit me and would often tell Derek, 'Tell Romilly to try on such and such a suit' or 'Tell Romilly to try that particular shawl with such and such a dress'.

I think maybe because I was leading such a conventional life in some ways as a politician's wife, and participating so much in what was then the current establishment, it was fun to have something irreverent, but classical. The clothes always made me feel as if I stood out from the crowd. Within those circles, Vivienne was considered outrageous and avant-garde. My view is that she was always not so much outré, but ahead of her time. And I wanted to support a British designer. So you got the whole mix with Vivienne. It was perfect for me.

MG: What do you remember about meeting Vivienne Westwood for the first time?
RM: I must have met her in the shop originally. I remember how extraordinary she looked. She was always very down-to-earth and fun. I liked her unassuming and uncomplicated manner. Though she had her intellectual side, too. She always spoke in a rather flat voice and her conversation was peppered with historical and philosophical references. And she cared so much – about the tailoring and the detail. Once we met by appointment for tea in the Westbury Hotel next to her Conduit Street shop. Vivienne appeared on her bicycle with three assistants in tow, with a scarf tied jauntily round her head, a short tartan skirt, high check gingham platform shoes and an extra-tight jacket with peplum. It looked marvellous.

She was always so generous and very kind. When I wore one of her outfits for the Opening of Parliament,[7] in the

morning she sent round a silk gauze shawl she thought would look nice with it. It was so thoughtful. And it shows her concern as a designer for the total look.

MG: Have there been times when you got involved, when you personally have influenced the clothes?
RM: I remember Vivienne coming round to our flat in London and my husband, Alistair, had just started collecting beads. Vivienne came round for coffee and asked if it would be all right if she used some for her next show. We said, 'Yes. Of course'. It was exciting to watch her going through them and picking out individual beads and rows of beads so carefully and thoroughly. She took them away and the next time I saw them was in the show, done up into these amazing belts and necklaces.

Vivienne has always been so creative. And it's her, entirely her. She doesn't get assistants to do that sort of thing. She has to have the last word. There was a diamanté codpiece that was shown in Paris and, quite literally, as the model was waiting to walk down the runway, Vivienne was sitting there sewing on the last diamond before it went in the show.[8] I don't know any other designer who does that. They might fuss about what goes with what, but not the actual minute tailoring side of it. She's such a talented craftsman. I can't think of that word applying to any other designer.

MG: Tell us about Vivienne Westwood on the larger stage.
RM: In the late 1980s, I attended my first Vivienne Westwood show at Azzedine Alaïa's showroom in the Marais in Paris. Azzedine had always been a great supporter of Vivienne's and had kindly lent her his space to show her work. It was a small show and many of the promised customers and journalists did not attend. And as always, it started late. But I can tell you,

it was *electric* from the minute the first model stepped onto the catwalk.

All the early shows were in Paris. Vivienne never did show much in London back then. She was often mocked by the tabloid press. I tried very hard when I was with English *Vogue* to get the English press interested. But even when someone would say to me, 'Gosh you're wearing something smart' and I'd tell them it was by Vivienne, they'd just roll their eyes.

She also had a reputation for being difficult, though it had more to do with her unconventionality than anything. Only a few of the more knowledgeable commentators understood her work. But on the whole, the fashion journalists were just anti-Vivienne on principle. They found her and her organisation difficult to deal with and they had little comprehension of what she was trying to achieve. They still associated her with being outrageous and with the Sex Pistols and her Punk period. They had not moved forward, though Vivienne most definitely had.

MG: Are there any particular shows that stand out?
RM: One of the best was in the Grand Hotel in Paris. I was top to toe in pink tartan designed by Vivienne![9] I was trying very hard to promote her at the time and I deliberately wore that to all the other shows as well. I believed in her.

I wore her clothes everywhere. I can remember being told at various political functions, 'How brave to go out wearing that!' or 'It can't be Westwood – it looks so beautiful'. I couldn't understand why people found them so outrageous. To me they were just wonderful clothes, like any other wonderful clothes. I remember wearing a feather outfit to Norman Lamont's fiftieth birthday at No. 11 Downing Street in 1992.[10] I walked in and saw a lot of people in lovely outfits, but quite frankly, they just didn't stand out in the same way.

And I can remember at least three different red or red tartan outfits I wore for Christmas at Chequers. My husband and I went every year for eleven years at Christmas. Margaret Thatcher was a great admirer of Vivienne's clothes.

MG: Really?
RM: Always. She used to say to me, 'Now, who made that?' And I would tell her it was Vivienne Westwood and she'd say, 'Oh, she's one of our really good British designers'. She was always very supportive and always looked at the buttons and things.

MG: And do you think the tailoring has helped her endure as a designer?
RM: Absolutely. As my collection of clothes has grown over the years (I have now catalogued more than 1,500 items), what fascinates me more and more is the skill and detail. I collect different designers for different reasons: Jean-Paul Gaultier, Liza Bruce, Rudy Gernreich. But with Vivienne especially, it has always been the craftsmanship and the tailoring. With designers such as Gaultier, it is often the cut and the construction that makes the garment. But with Vivienne it's much more to do with her choice of materials and what she is willing to do with them, such as printing the designs on the rubber mac material or using the Fragonard print. She has invented tweeds, drawn up wildly different patterns. She's always playing with materials in that way.

MG: What about practicality?
RM: It was a revelation to me about Vivienne. You wouldn't think those ball gowns and things would roll up into a suitcase, but they do. They're meant to be in *some* disarray. You just take them out and give them a shake, and that's it. It is very clever. Some of the more tailored pieces did have to be ironed, but a lot of the clothes didn't. I could never understand why people didn't see it.

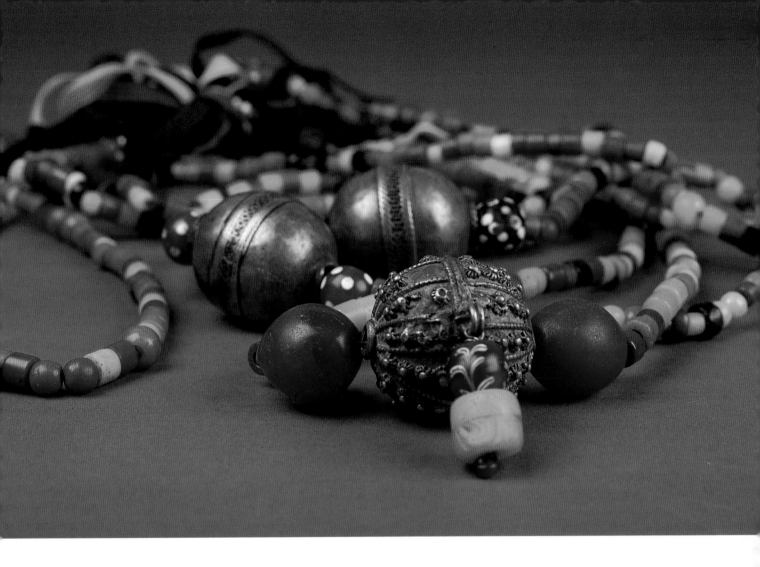

MG: *Do you think she has reached a stage where her reputation is properly recognised?*
RM: I don't. In some places, yes. The Japanese think she's absolutely wonderful and will pay lots of money for her second-hand clothes. If she's received any recognition, it invariably comes from abroad. She is very highly regarded by many foreign designers. Though I still don't think she's been appreciated in England enough.

MG: *What would that say about the British, do you think? Isn't there a paradox that Westwood, who is seen abroad as a very British designer, should fail to be fully recognised here?*
RM: Yes. We're supposed to be eccentric, but I think what we do is enable eccentric people to live and operate here without

really appreciating them. We tolerate and, in some ways, enable them, but we don't go out of our way to participate. People used to say, 'That looks lovely on you, but I couldn't wear it'. Thank goodness this attitude is finally changing and Vivienne's talents are being properly acknowledged.

MG: *Her popularity has certainly increased. Has the industry offered her like recognition? Has Britain?*
RM: In part. She has twice won the British Designer of the Year award. I think though that Vivienne should be made a Dame. She has been the doyenne of British fashion for the second half of this century, certainly. Who else has been as influential?

MG: *And she stayed here.*
RM: I can't think of anyone more deserving.

Wearing Westwood

'We expect clothes to say more than "I am wearing a smart outfit". Which is why we have Vivienne Westwood'.

Sarah Mower, 1991

Di Atkinson, born 1955
Historian

My first two pieces of Vivienne Westwood were given to me by her as a present from the *Buffalo* days. I knew her brother and family quite well, so my immediate contact with Vivienne was not really as a designer but as a friend. I am wearing an early piece from the mid- to late 1980s: a black crinoline, a mini-crini. It makes great shapes when you wear it. It's not the easiest thing to travel with on public transport because it will fly up over your waist and shoulders if it's in that kind of mood. But it's great fun.

Patrick Hughes, born 1939
Artist

Vivienne Westwood's men's clothes are manly, very striking. Her suits are a kind of parody or elaboration of men's tailoring. As a painter, I spend most of my days in a T-shirt and chinos, so I dress up in the evenings or at weekends. I've had this warm winter suit for three or four years and I'd wear it anywhere. I don't mind being over-dressed and attracting comment. I'm of the Beau Brummell school. I think men should dress up.

Photographed at Great Eastern Street, Shoreditch

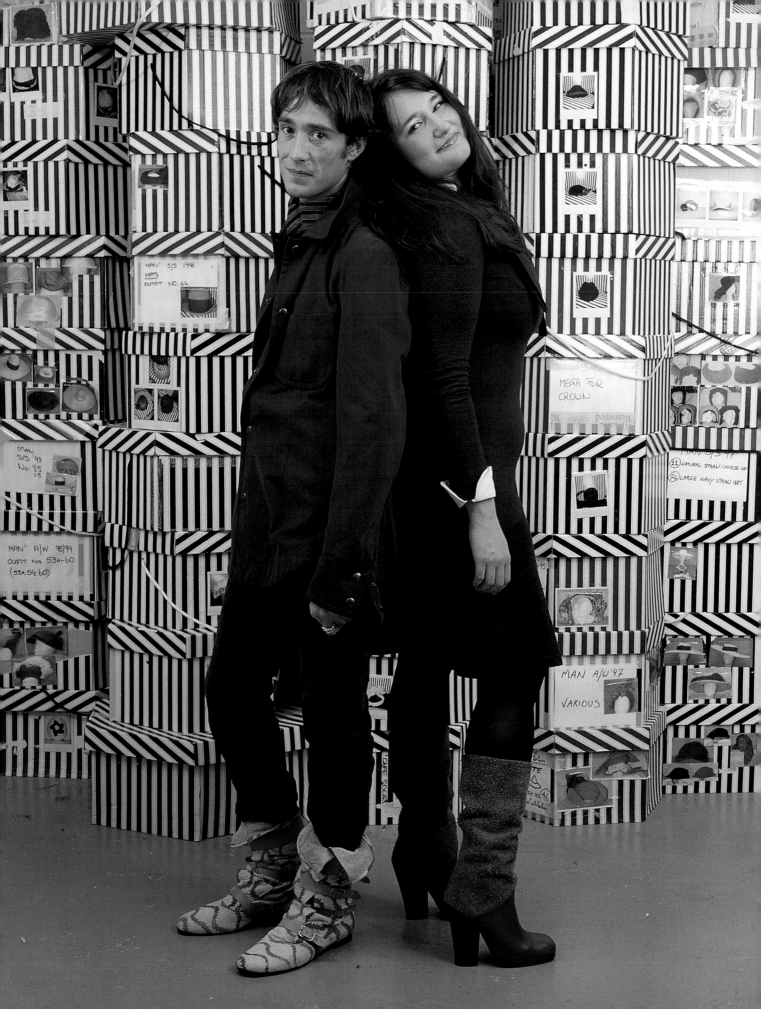

Andrea Cameroni, born 1971
Westwood Assistant Designer

It was when I was seventeen and going clubbing in Italy that I first discovered Vivienne Westwood. The first piece I bought was hand-knitted with slashes over the body and gold foil around the neck and cuffs. It was beautiful. Now I live in London and travel to Italy and I'm still wearing Westwood. Here I'm in Pirate boots from the 1980s, blue cotton trousers, a jacket and a striped Krall shirt.

Victoria Clarke-Ames, born 1972
Westwood Archivist

What I love about Vivienne is that she wears her own clothes all the time, not like some designers who say 'wear my clothes' and are only ever seen in a black T-shirt and trousers. I remember in college my tutor called her Vivienne Wedgwood by mistake, because of those big wedge shoes she was designing! I'm in my Moscow dress as worn by Ivanka Trump in the Autumn/Winter 1999 *Red Label* show. It has detachable collars and cuffs and is a sexy mix of schoolgirl and schoolteacher.

Photographed at Vivienne Westwood Studios, Battersea

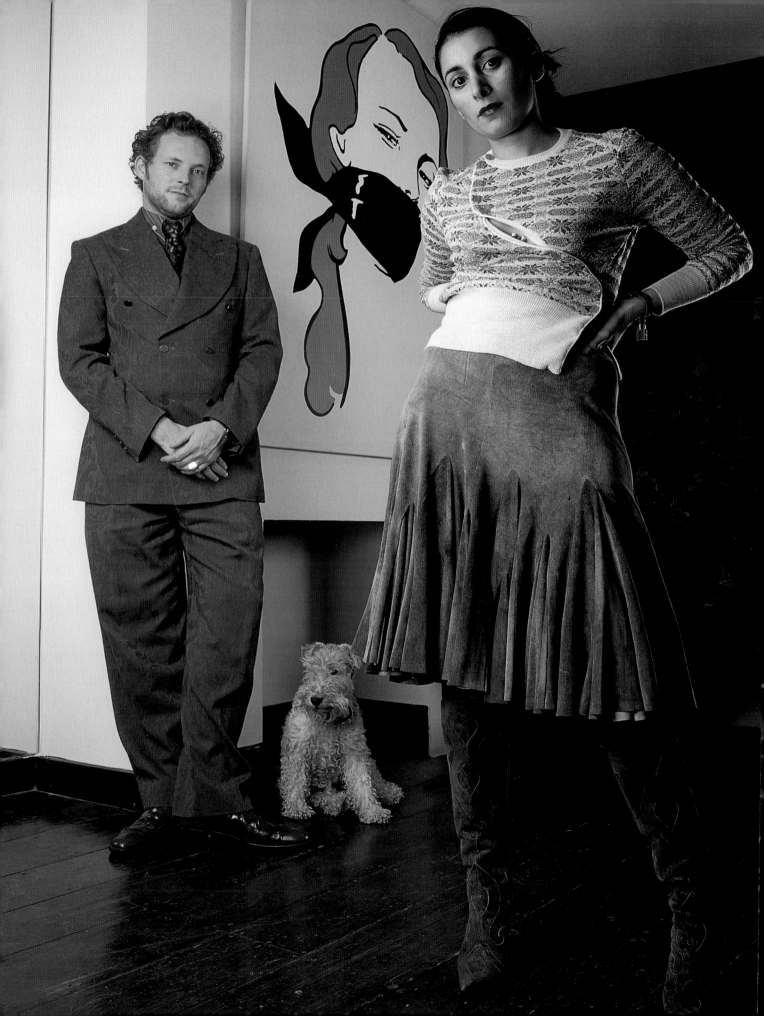

Joseph Corre, born 1967
Agent Provocateur

I have been wearing my mother's clothes since I was a kid. In the Punk times, they were a kind of uniform to let people know whose side you were on. I loved that. They created a recipe for adventure and separated you from the crowd. When I was older, they gave me a free ticket into any club or party I wanted to attend. All you had to do was turn up looking fabulous.

Serena Rees, born 1968
Agent Provocateur

One of the most exciting things about wearing Vivienne's clothes is that one discovers a new person inside oneself. It is a little like being Cinderella – becoming beautiful, elegant and sexy all at once. It amazes me how clever she is, the way she takes a simple piece of fabric and creates something so beautiful with just a simple drape or fold. I've learnt a lot through wearing her clothes, not only about myself but about other people as well, and even a little history. It's a thrill to wear her clothes. I'm hooked!

Photographed at Agent Provocateur, Smithfield Market

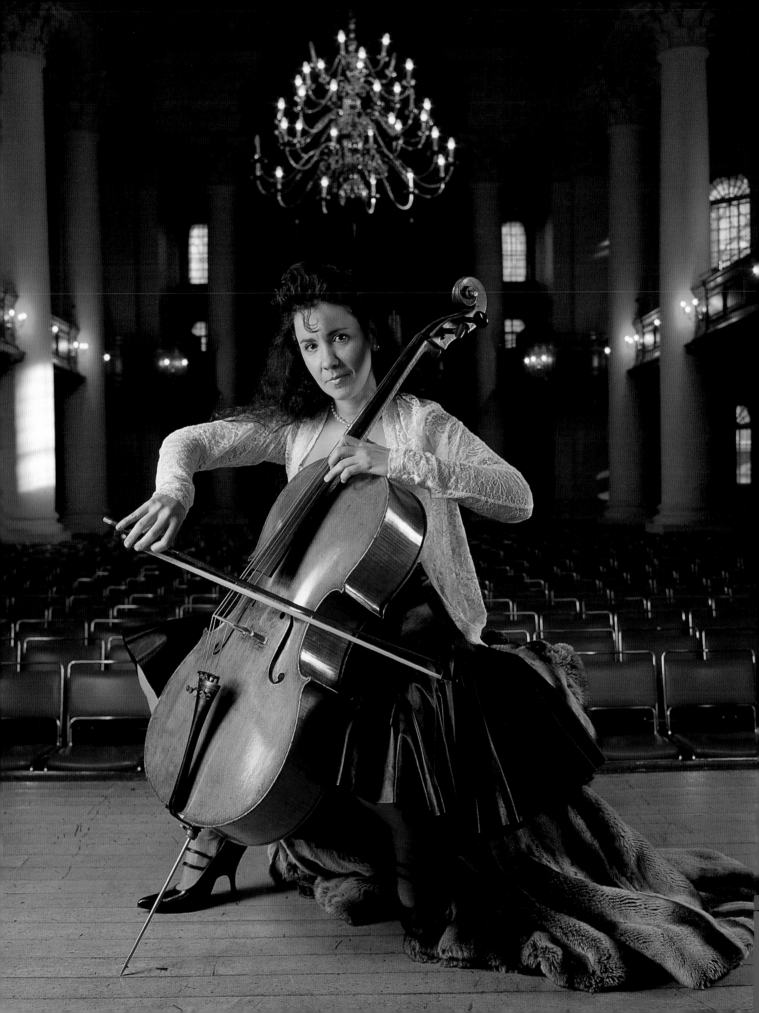

Soujâtâ Devaris, born 1962
Cellist

It was an operatic costume designer, appropriately enough, who encouraged my boyfriend and I to have a look at Vivienne Westwood. We went along and were very excited. The clothes are beautifully cut, works of art really. As someone who performs on stage, I respond to their sense of theatre. I'm wearing a lace bustier, a historical piece which adds reminiscence to some of the baroque and romantic music I play. The top is lace with diamanté buttons and the black leather skirt has piecing and gores which make it practical for a cellist and distinctive as well. I tend not to mix my Westwood clothes with those of other designers; I feel they deserve a kind of respect. I think she will last, just like the great composers.

Photographed at St John's, Smith Square, Westminster

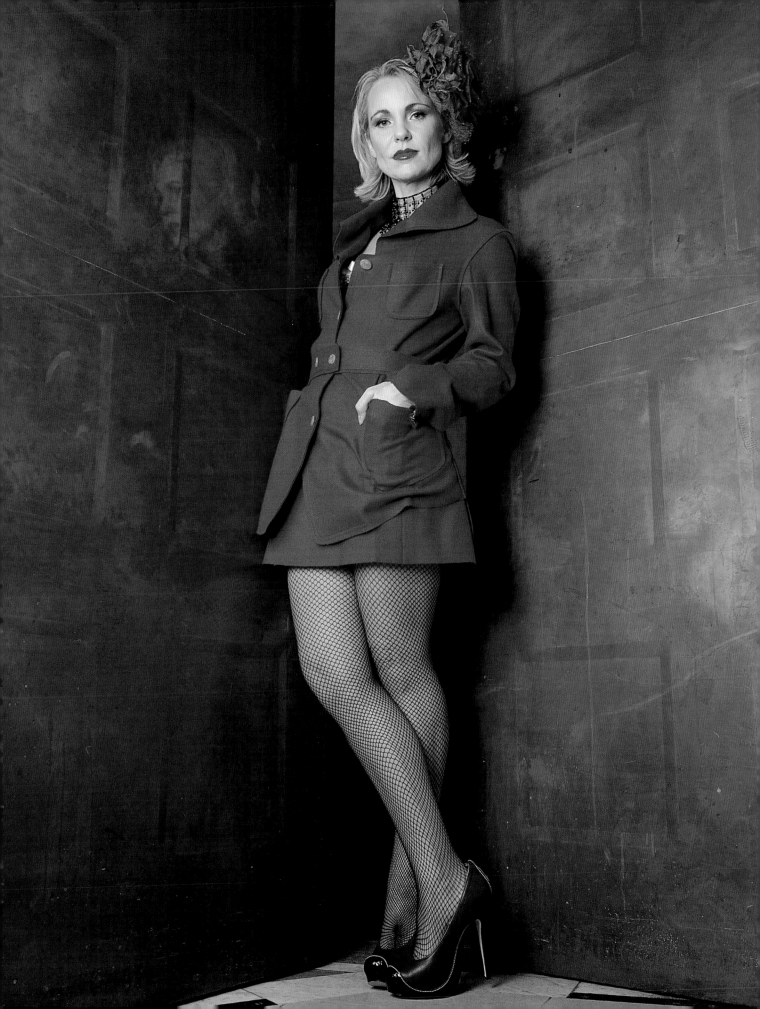

Amanda Eliasch, born 1960
Photographer

For years I went into Vivienne Westwood shops just to look. They are brave clothes and I never thought I could wear them, until one day, I was persuaded by the shop assistant to go for it. I did, and I've bought masses ever since. I like shape more than colour, and Vivienne Westwood makes women's figures look fantastic. She gives you curves and character. I'm wearing a belted red jacket with a matching short skirt and patent leather stilettos. The clothes are wonderful for everything: for parties, to photograph, to live in. Perhaps not for putting up lighting equipment, but they're good for everything else!

Photographed at Chester Square, Belgravia

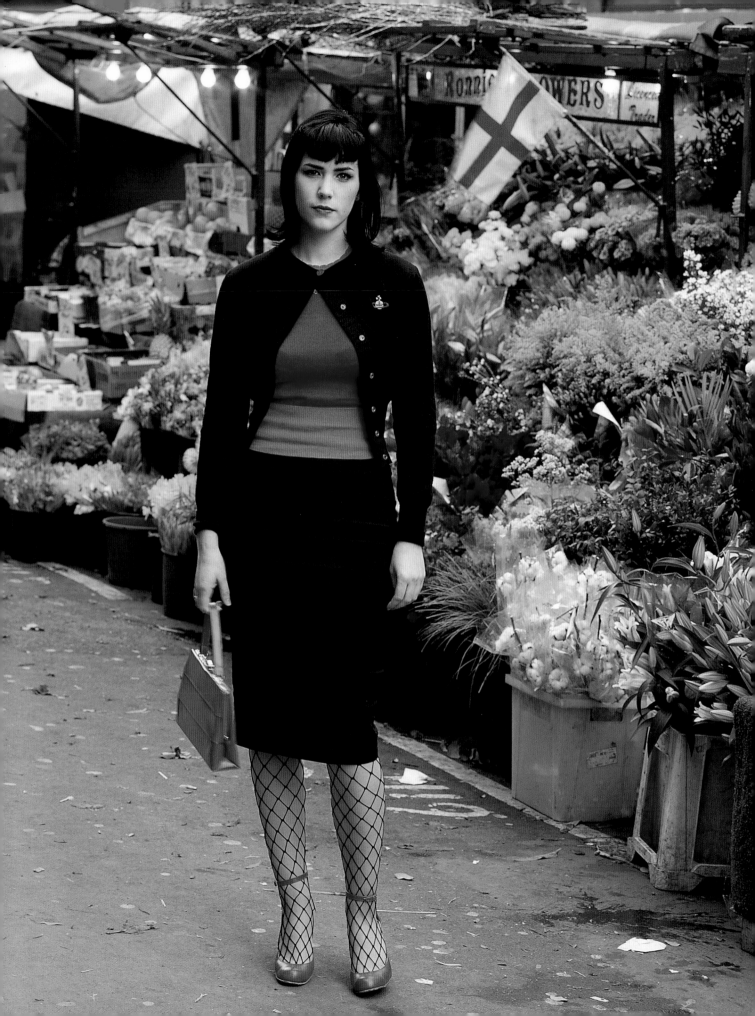

Cecilia Fage, born 1976
Design Graduate, Central St Martin's

I'm wearing my basics. I've got a couple of shirts which are more flamboyant, but these tops are very versatile. The shoes I'm wearing are my favourites: my red tart shoes. They are very unusual and show off your toe cleavage. I've had people say, 'Oh my God, they're amazing, I've never seen anything like them before!' Most of my clothes are pretty impractical, so these shoes are perfect! Vivienne Westwood clothes don't hide the figure, they accentuate it – as with this cardigan which is pulled in at the waist. Her designs are unique. Whenever I have a chance to celebrate, I treat myself to something from the Vivienne Westwood shop.

Photographed at Berwick Street Market, Soho

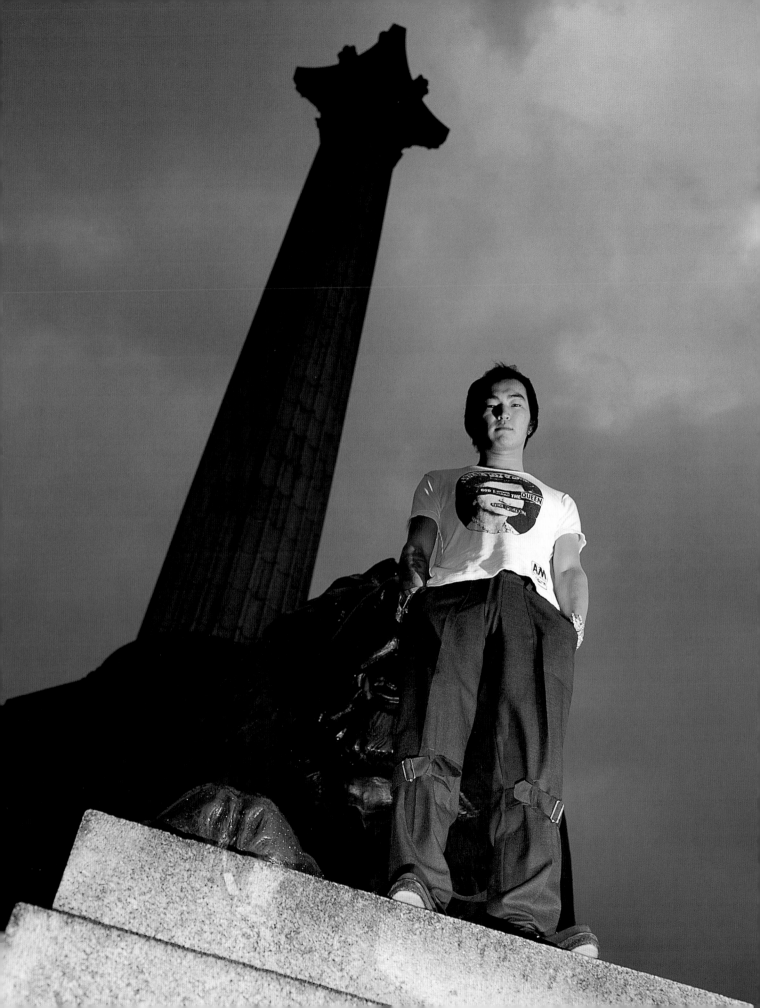

Shoji Fujii, born 1972
Photographer

The T-shirt and trousers I'm wearing are only one aspect of my Vivienne Westwood collection. I used to wear suits, but I can't now because of my work. At its peak, my Westwood collection numbered over two hundred items, including ladies' suits and dresses and even the shoes in which Naomi Campbell fell down on the catwalk in 1993. I bought a few pieces in Japan but they were too expensive there. My first purchase was a pair of white bondage trousers when I was eighteen. I had noticed her clothes before then, but hadn't realised they were by Vivienne Westwood. I am more interested in the background to her design than the clothes themselves, in her ideas. I admire her as a revolutionist.

Photographed at Nelson's Column, Trafalgar Square

David Hart, born 1978
Barman

I've always loved Westwood clothes, their luxury and opulence, their Englishness. I remember seeing clips of her shows on television when I was younger and being fascinated by what she was doing because it was so different from everybody else. I don't think there's another designer who can make you feel so transformed, even if you're just putting on a plain white T-shirt with an orb on the front. Although I love wearing Westwood, I can't afford to buy it, so I borrow all my flatmate's Westwood clothes. I often go shopping with him to choose pieces and then I end up wearing them. My favourite piece is a white leather belt with a golden orb clasp. Unfortunately it belongs to a girlfriend with a 26-inch waist, so I can't borrow it!

Photographed on the Barbican High Walk, City of London

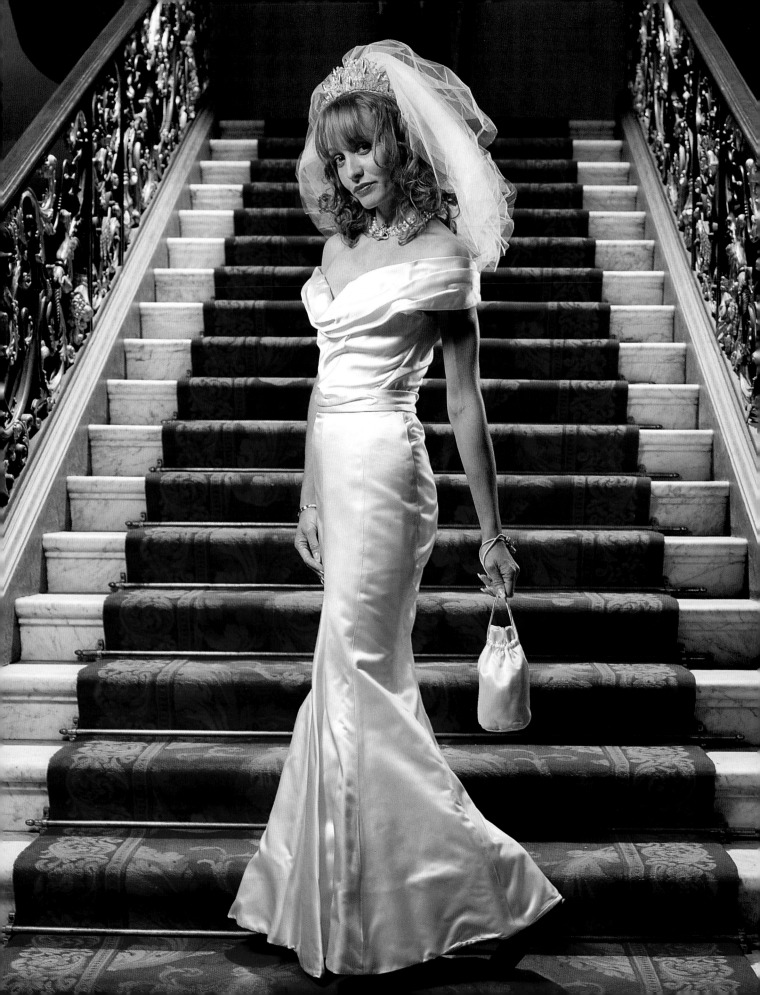

Amanda Lucas, born 1968
Former model

I first modelled Westwood at her *Buffalo* show at Olympia in 1982. I was only fourteen and too short to go out with the other female models. So Vivienne sent me out with the men instead, in her way-out clothes with bits of hessian wrapped around my ankles. I love the way she gives women a really feminine curvy shape with a bust and hips. When I got married two years ago, I commissioned the Westwood studios to combine a bustier with a lovely Westwood skirt I'd seen. This is the result, a fitted dress of cream Duchess satin that flares out at the bottom. There's a matching bag – which gave me something to do with my hands! Vivienne also designed the veil, which is short, unfussy and fun.

**Photographed at the Wallace Collection,
Manchester Square, Marylebone**

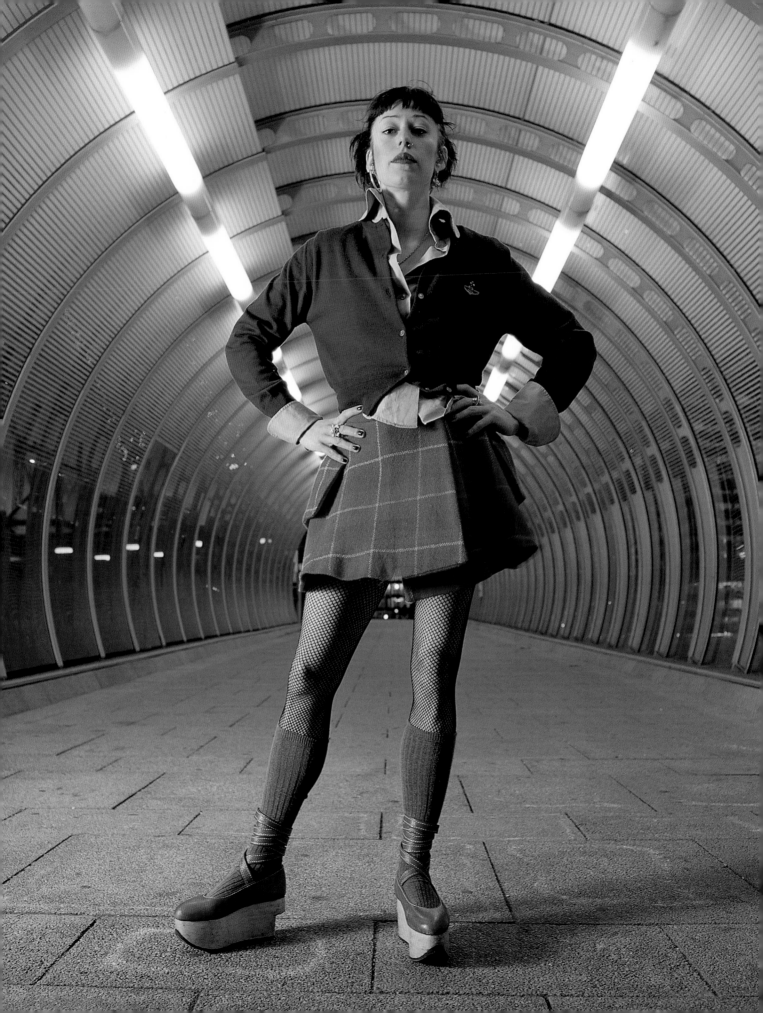

Joanna Massive, born 1974
Dance record store owner,
Massive Records

Since I was a child, I have admired Vivienne Westwood's work and thought she was an amazing woman. My first purchase was a white jersey mini-dress in 1992, followed by my first pair of Ballerina Rocking Horse shoes. Ever since, I've been hooked and I now buy my favourite pieces from each season's collection. I adore Vivienne's tailoring and design technique and the way the clothes make you feel ready to take on the world. This Riding skirt is one of my favourite suit pieces and is an example of what I normally wear during the day, along with a shirt, cardigan and my staple, these Rocking Horse shoes.

Photographed at Poplar High-Level Walkway, Poplar

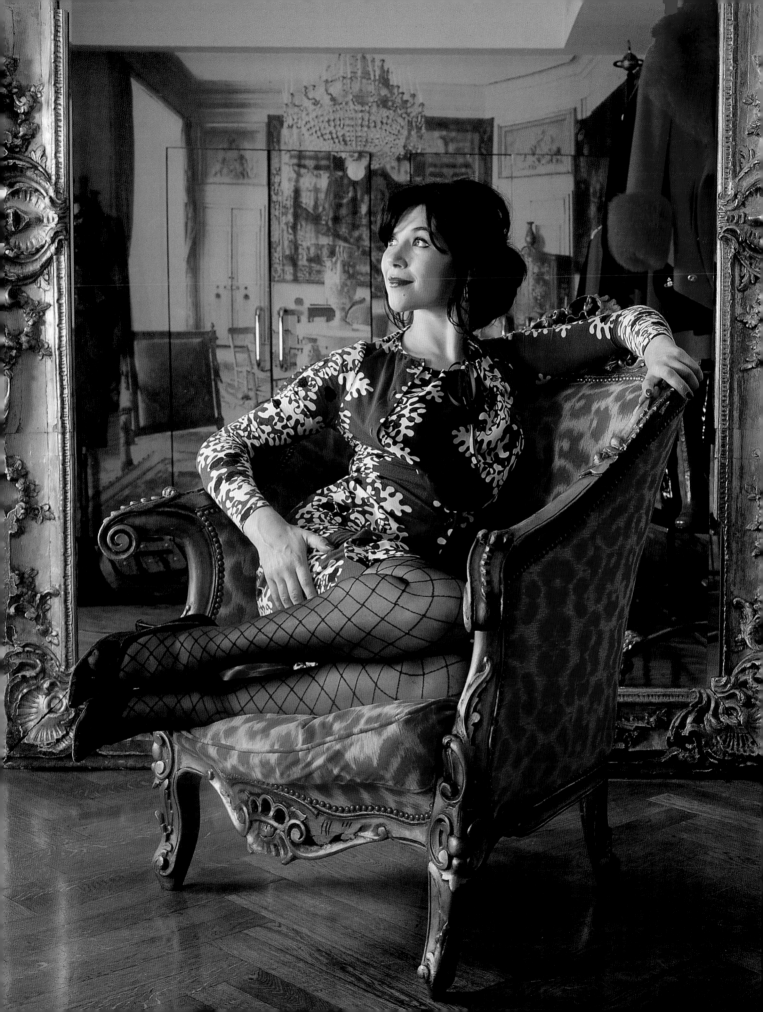

Jessica Morris, born 1968
Press Officer

When I was a teenager shopping in Camden, my mother pointed Vivienne Westwood out to me one day as she rode past on her bicycle. I remember her looking incredible. Everyone looks individual in Vivienne's clothes. They're beautifully made and can change the whole silhouette of a person. I feel I'm dressing more for myself than following the current trends or fashion. The dress I'm wearing is one of my favourites. It's a cosy winter dress from the 1998 Autumn/Winter collection, *Dressed to Scale,* and is made of stretch jersey with a georgette insert at the front. The acorn print is blown up from a Matisse painting. I love this dress. It's sexy but not revealing.

Photographed at Vivienne Westwood Ltd, Conduit Street, W1

Yasmine Nouaisser, born 1967
Property Developer

A few years ago, a dress in the window of a Vivienne Westwood shop caught my eye. The warm colours, gentle fabrics and suggestive design were so incredibly feminine that I simply had to investigate further. I've been a faithful client ever since. I believe her clothes capture the true essence and spirit of femininity, and in turn bring out the lady in every woman who wears them. In short, her designs for women are unmistakably feminine, unmistakably Westwood! I have great admiration for Vivienne Westwood and I believe she is a true credit to the British fashion industry.

Photographed at Warwick Square, Pimlico

Yoshii Ohta-Jones, born 1969
Student

I'd always been attracted to that British sense of 'cool' in music and art and fashion. It was Vivienne Westwood, in fact, who made me change my course of study from photography and painting to fashion. When everyone was heading toward minimalism, Vivienne Westwood's clothes were the complete opposite. Her designs are fanciful and full of life – that's what makes me think she's a great artist. I used to wear Vivienne Westwood to clubs in London and especially love the mid-nineties collections. What I'm wearing is more recent: a 1998 *Gold Label* knit skirt and shoes from the Spring collection. I like to mix different Westwood collections and also match her clothes with second-hand or other retro items. When I go to a party, my Westwood clothes take me into a fantasy world.

Photographed at World's End, King's Road, Chelsea

Steven Philip, born 1961
Shop Owner

My first Westwood purchase was a pirate sash from the early eighties. It was only later that I really got into the entire range of Westwood, selling second-hand clothes at Portobello and Kensington markets. I started off doing seventies tops and Punk reproductions, but then I changed the whole stall into a shrine to Vivienne. I got videos and studied all the collections and I uncovered an amazing amount of vintage Westwood in circulation. People used to stop dead in their tracks. They'd be flabbergasted at the stuff Vivienne had created, especially when they'd only come out to look for an old fleece jumper. Wearing Vivienne's clothes, the cut and fabrics are so special that people get the attention they crave.

Photographed at Rellik, Golborne Road, North Kensington

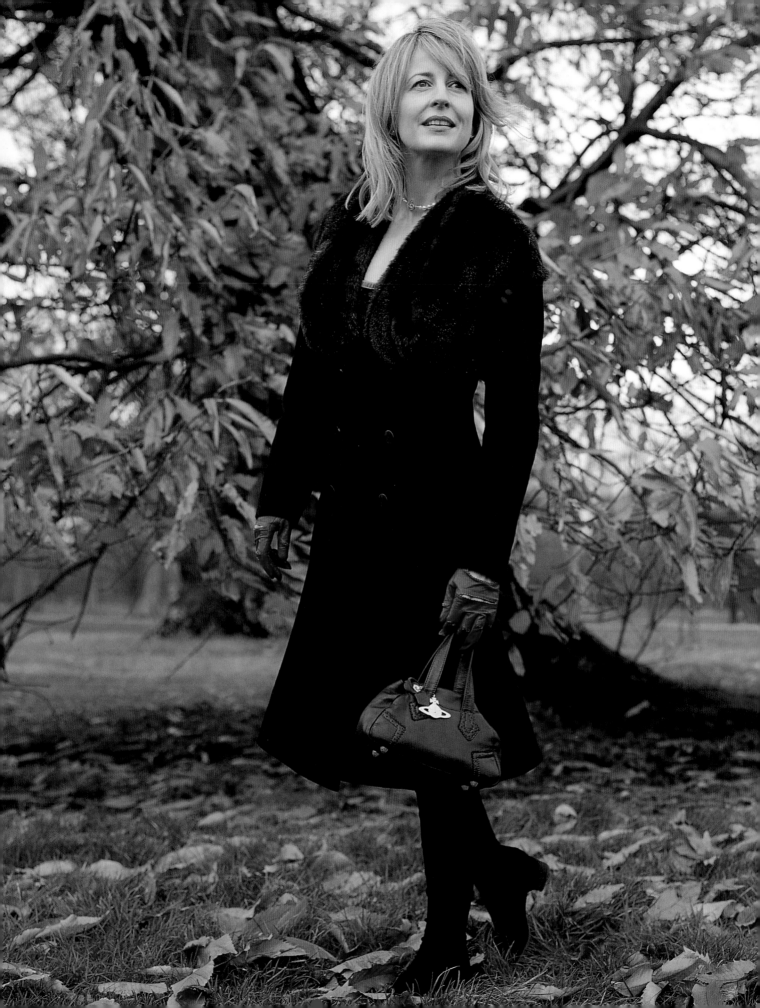

Cherry Pryde, born 1962
Restaurant Reviewer

I used to wear Vivienne Westwood clothes in the evening. Now I wear something of hers every day, which often attracts comment. This coat and gloves and even the handbag have something very sexy about them and I feel deeply feminine wearing her clothes. I have not come across a designer who cuts like her or is doing what she does. With each new collection, I wonder how she will keep on designing ever more original and beautiful shapes. Sure enough, she pulls it off every time. I recently bought a shirt which has enormous buttons with her crown and orb logo embossed on them. One of the buttons came off and now sits on my sofa table as an *objet d'art*.

Photographed outside the Serpentine Gallery, Hyde Park

Philip Sallon, born 1951
Event Organiser/Socialite

My sister first took me into the King's Road shop, 'Let it Rock', in 1973. My favourite clothes back in the seventies were Vivienne Westwood's bondage suits in different colours with a strap tying the legs together. People used to ask, 'How do you run in those things?' To which I'd reply, 'I get a taxi, darling!' Vivienne's not afraid to be outrageous and I wear her to be avant-garde. She doesn't compromise like other designers. In the eighties, she refused to put large shoulder pads on her ruffle shirts to make them look contemporary. She's able to stand apart from current trends, so her designs don't look dated as the years pass. I'm wearing a Westwood shirt from her shop and a hand-painted one-off satin suit that I bought for about a hundred quid off a friend. I buy a lot of her more garish stuff in the sales and mix it with other Oxfam clothes. I just think she's excellent.

Photographed in the Poyle Park Room, Museum of London, City of London

Tiger Savage, born 1968
Art Director, M&C Saatchi Ltd

My mini-crini with my ermine shawl and my crown is one of my favourite Westwood outfits, though it's not the sort of thing you can wear to the office every day. What I'm wearing here is a little more conservative. I'm known for wearing Westwood. I once came out of a Japanese club at three in the morning and an entourage of girls began to chant, 'Vivienne Westwood, Vivienne dress'. It was great. I don't like to be ignored, so the clothes go with my personality. Vivienne also designed my wedding dress: a beautifully beaded bustier with a fishtail Mae West skirt and a jacket over top. The beaded collar came up high over my head – sort of Elvis Presley as an Elizabethan, or Snow White goes to Vegas. Everyone loved it. Vivienne made me a pair of lower heels for the evening, but I wore my six-inch stilettos all night!

Photographed at The Ivy, West Street, Covent Garden

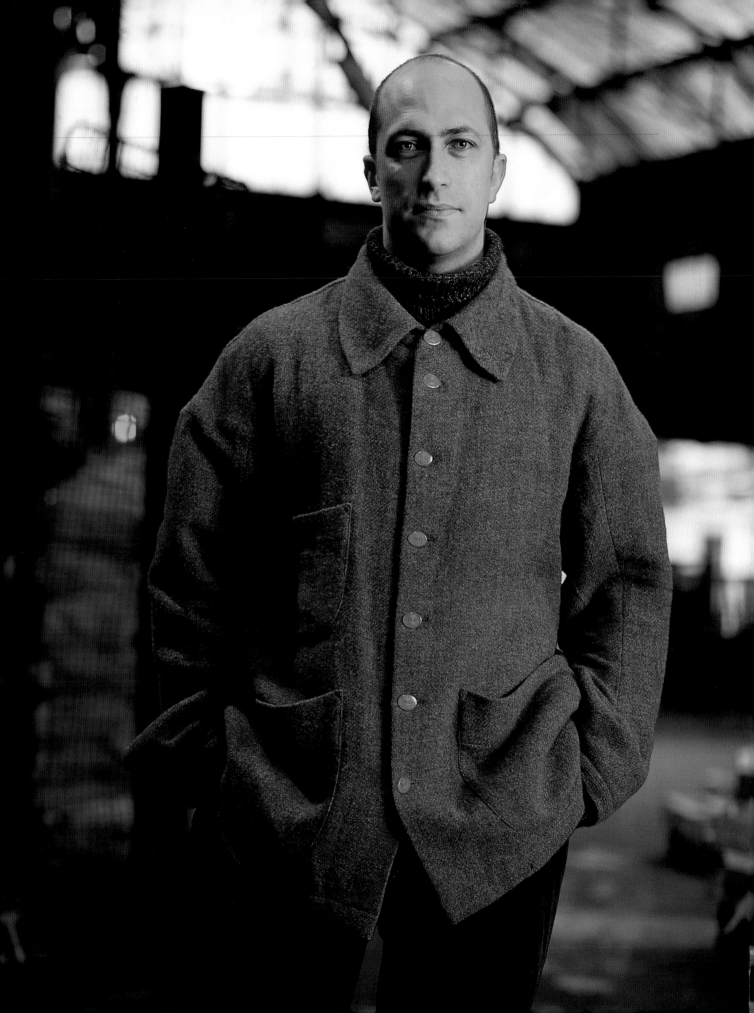

Rod Taite, born 1966
Photographer

I first noticed Vivienne Westwood when Janet Street Porter's LWT show did a feature on Malcolm McLaren and the Sex Pistols in the seventies. I generally try to find Vivienne Westwood clothes second-hand because they're the best value that way. The jacket I'm wearing came from a second-hand shop in New York's Greenwich Village. What I love about the style of the jacket is that it's such an unusual shape for a man's piece. I've never seen anything else like it anywhere. Apart from its shape, my favourite things about the jacket are its colour, a textured deep brown/green, and the warm wooliness of the fabric. And how do I feel when I wear it? Absolutely fabulous, darrrrlink!

Photographed at Borough Market, Southwark

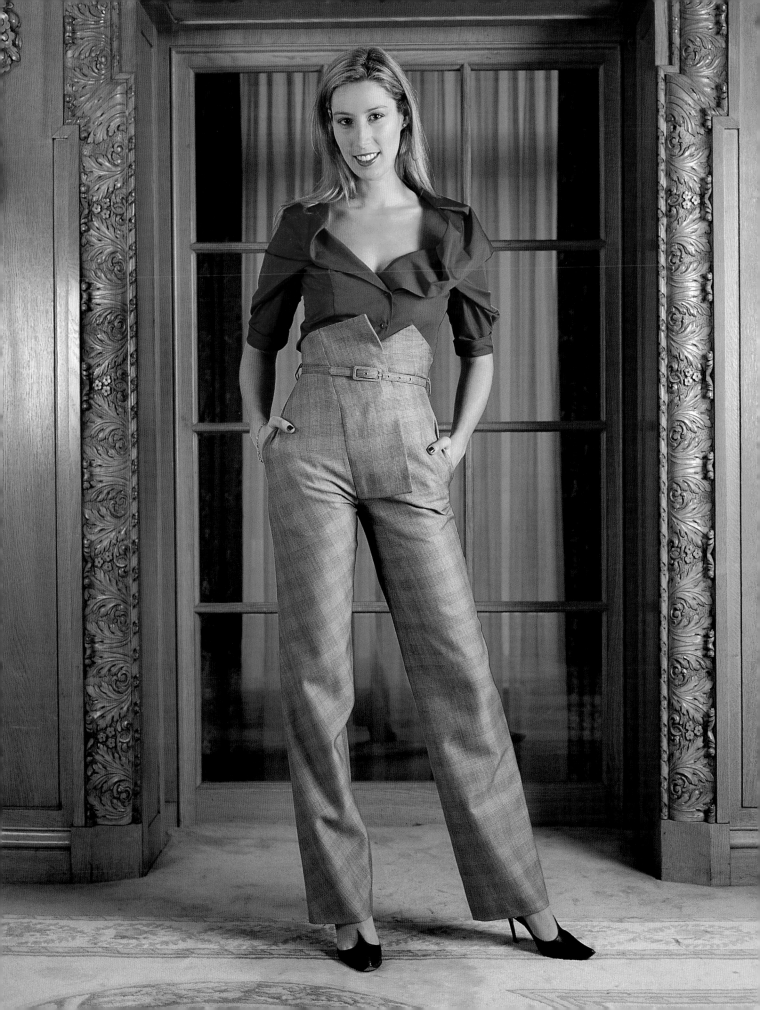

Aude Taittinger, born 1977
Socialite

I first encountered one of Vivienne Westwood's shows two or three years ago in Paris. It was exceptional and really stood apart from the standard collections shown during those fashion weeks. My first Westwood outfit was a little black cocktail dress. It is such a treasure. I have worn it dozens of times and each time I feel sexier and more feminine. The magic still works! In my opinion, Vivienne Westwood does not sell contemporary or trendy outfits. She sells attitudes: well-being, comfort, elegance and self-confidence. She definitely emphasises the forms and shapes that make a woman exclusively female. Even a pair of Westwood trousers and a shirt worn during the day can make you feel like a diva! I really do think that thanks to her, I have found my own style.

Photographed at the Berkeley Hotel, Knightsbridge

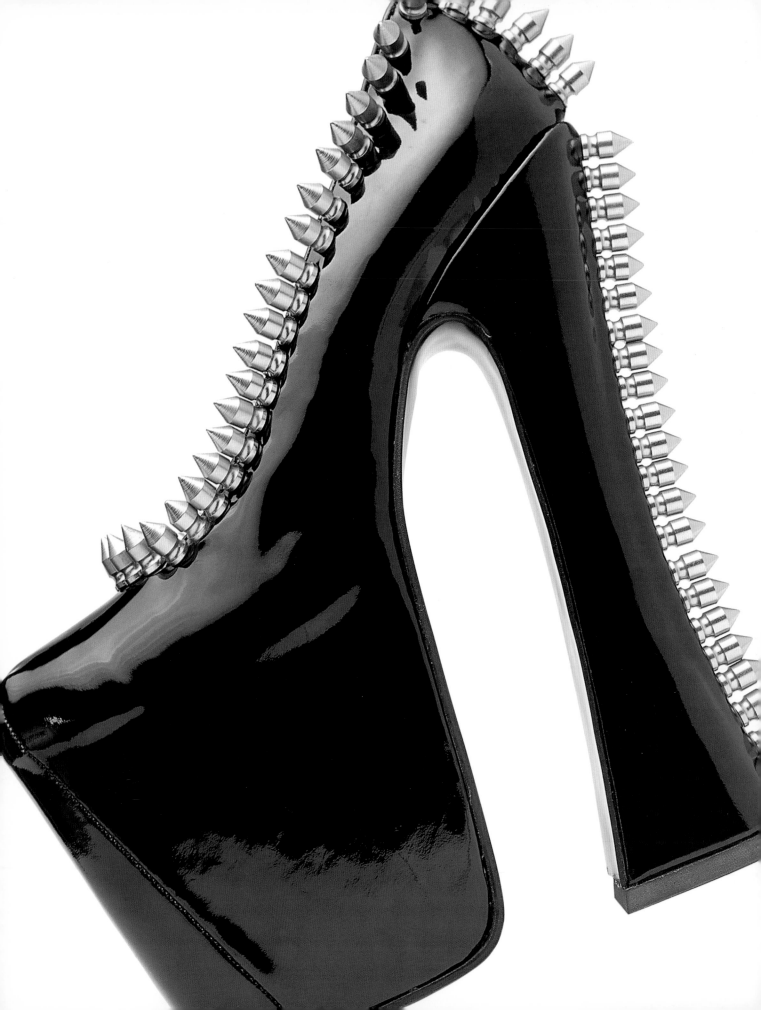

Making Westwood

'Although her clothes often stretch the boundaries of acceptability, her starting point is always historical, working within a tradition that even the tailors of Savile Row might appreciate'.

Roger Tredre, 1991

Cut and construction

Edwina Ehrman

Vivienne Westwood would be the first to acknowledge the inspiration she derives from the past, whether through literature, art or surviving costume. Although she has a reputation for challenging conventional forms of dress, her research has reinforced her respect for traditional methods of making, teaching her the techniques she needs to translate her ideas into the reality of cloth. In looking to the past, she joins a long line of dressmakers and designers who have used it as a source of reference and to add meaning and authenticity to their work.

Westwood believes passionately in the value of knowledge. She is a tireless self-educator and a dedicated teacher. From 1989 to 1991, she was Professor of Fashion at the Vienna Academy of Applied Arts, and since 1993, she has taught in Germany as Professor of Fashion at the Berliner Hochschule der Künste. She is adamant that technique precedes creativity and that fashion students should start by studying and copying historic garments to inform their practical skills and instil a disciplined approach to design. Well-trained and highly skilled staff are vital to the success of her business.

Westwood uses her detailed knowledge of historic dress to create garments that have a rapport with the body and allow her to explore her interest in changing ideals of beauty, contemporary femininity and female sexuality.[1] She also uses it to inform her choice of fabric, trimmings and surface decoration. Her interest in the sixteenth and seventeenth centuries manifested itself in a series of slashed garments made from leather, denim and stretch fabrics, in doublet-style jackets and in men's and women's wear provocatively decorated with plump, beribboned codpieces. Although a perfectly correct historical accessory for men, Westwood's playful use of the codpiece was undoubtedly intended to be risqué, reflecting the bawdy, kitsch side to her design. From later centuries, she has taken the corset, crinoline and bustle, moulding and displaying the body to create a shape that her customers find ultra-feminine, sexually empowering, and absolutely appropriate to the present day. Westwood herself is intrigued by the power of clothes to 'control' the body, and her development of underwear as outerwear has been hugely influential. At her most innovative, she has created clothes that retain the essential character of their historical source whilst working in an identifiably modern idiom.

Left
Romilly McAlpine in Vivienne Westwood day wear. Dangerous Liaisons jacket printed with tulips, *Erotic Zones*, Spring/Summer 1995, worn with a Super Sarah Bernhardt blouse, *Café Society*, Spring/Summer 1994

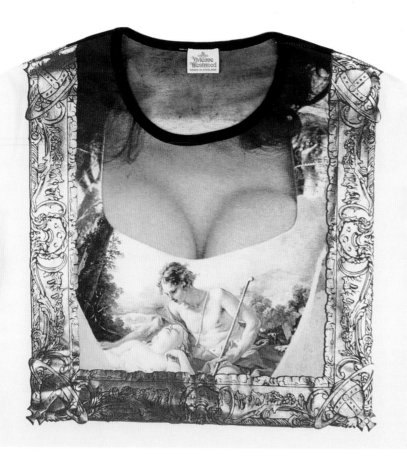

Art has also played an important role in her design, from revealing historical nuances of style and the changing proportions of the idealised female nude to representations of the erotic. Westwood's choice of Rubens's turbulent and violent image of *The Rape of the Daughters of Leucippus* to decorate a silk shawl demonstrates her fascination with the unclothed body, stripped of its fashionable attire but reflecting the fashionable silhouette, and her concern with shifting ideals of female beauty. The sisters' luxurious, soft, pillowy flesh carries a promise of their fecundity, and as Rubens's public would know, both bore sons to their abductors. Health and fertility are as important to their beauty as physical appearance.

Art can also provide an instant source of decorative print. Some images, such as Pierre-Joseph Redouté's watercolour drawings of roses and other early botanical illustrations, are sympathetically rearranged and transferred to fabric. But the indiscriminate use of photographic prints of old master paintings on everything from neck ties to peek-a-boob T-shirts can also trivialise the originals, mocking the endless reproducibility of art and commercial fashion.

The McAlpine Collection demonstrates the wide range of sources that Vivienne Westwood has drawn on and some of the ways in which she translates these influences into clothes that are both striking and distinctive. The following garments illustrate her knowledge of historic costume, its cut and construction and her gently subversive use of traditional fabrics. They also highlight the importance she places on creating a dynamic relationship between the body and its clothing and, importantly, Westwood's view that fashion should be frivolous and fun.

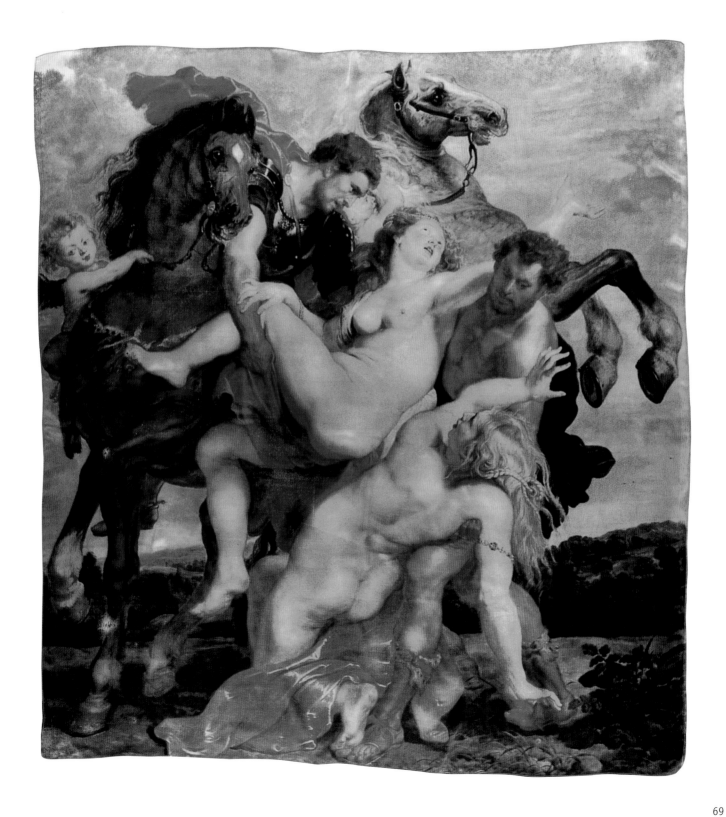

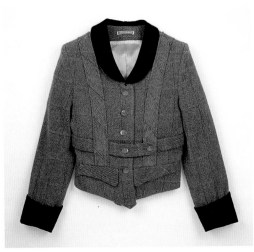

Shooting Jacket

Time Machine, Autumn/Winter 1988
Breanish tweed trimmed with cotton velvet, lined with viscose

This snug-fitting, boyish jacket plays with ideas of gender and class and encapsulates the Britishness of Westwood's style. Tailored in tweed, a traditional British fabric, it displays her talent for reworking historical styles to create modern, wearable garments.

It is based on the Norfolk jacket, a classic informal style worn by adults and boys for sporting and country wear from the mid-1870s to the 1920s. It can still be seen on the grouse moor today. Women wore them for walking, cycling, golf and shooting.

Following surviving examples, Westwood has replaced the jacket's original distinctive box pleat in the centre back and two pleats at the front with two bands of tweed running from the waist. These bands and the pocket flaps are bias-cut, creating a visual friction with the pattern of the body. They also provide loops for the belt, which Westwood has placed beneath the bust. There is no shaping for the bust and the jacket flattens the chest, creating a gamine silhouette. The belt fastens with two buttons, one of which acts as a double fastening, closing the jacket as well as the belt. Similar men's Norfolk-style tweed suits, worn with plus-twos and cut with a small shawl collar and a sweetly feminine curve to the basque, were also shown in the 1988 collection. This manipulation of traditional male and female styling adds a piquant sexuality to many of Westwood's clothes.

Westwood favours tweed for its subtle range of organic colours, its tactile qualities, and its romantic associations with Britain's rural past, when its durability, warmth and resistance to weather were prized attributes.

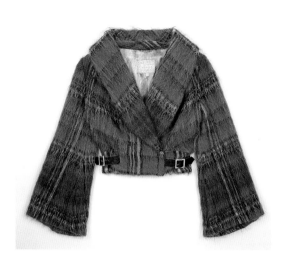

Hugger Jacket

Gold Label *Anglomania,* Autumn/Winter 1993
McAndreas tartan mohair wool, lined with hair-print acetate

The McAlpine collection includes a number of tartan suits, blouses and jackets. Tartan has become a Westwood classic, which she relishes both as a traditional fabric and as a glamorous, alternative form of male dress. She has become expert at manipulating the fabric to create flamboyant outfits in a kaleidoscope of checks. The McAndreas tartan, designed by Westwood, is named in honour of her husband, Andreas Kronthaler.[2]

This tartan has been woven in sleek heavy mohair to create a cropped jacket with a blouson back. A pair of unpressed pleats hidden by the collar adds fullness to the front. The deep shawl collar gives the jacket a wide easy neckline echoed by the long flaring trumpet sleeves which fall to the knuckles and draw attention to the fingers. Only the back panels are set into the waistband, which conceals a small watch pocket on the left-hand side. The front panels are cut to the waist to accommodate the full sweep of the collar. The jacket closes with leather kilt fastenings which cinch and define the waist. The use of Westwood's signature hair print to line the jacket is both witty and sensual. The sheen and feathery down of the mohair are echoed in the silky tresses of the lining which cossets and caresses the wearer.

The jacket was shown on the catwalk with Argyll legwarmers, a micro-mini kilt and a belted plaid, creating an outfit whose sassy, sexy glamour grabbed the attention of the press. Its silhouette and raunchy mix of tartans recall the portraits of the Highland chieftains who from the seventeenth century chose to be painted with their plaids swirled about them, creating an unforgettably exotic and romantic image.

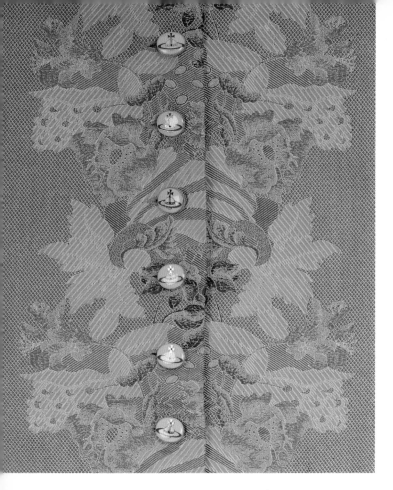

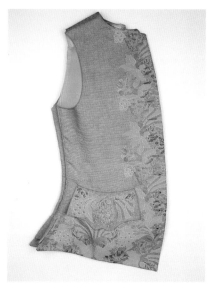

Dangerous Liaisons Waistcoat

Vive la Cocotte, Autumn/Winter 1995
Jacquard woven silk, lined with acetate

Westwood has frequently stated that the foundation of her craft lies in disciplined observation and the mastery of technique. She insists that her students start by copying garments in order to learn the techniques of cutting, tailoring and dressmaking and recommends that they copy paintings and draw from life to improve their skills of observation. So unpractised are we at 'looking' that Westwood feels it has become a 'revolutionary' activity.

This waistcoat is based on a surviving sleeved waistcoat made from silk designed by Anna Maria Garthwaite for the Spitalfields master weaver Peter Lekeux in 1747. The silk was brocaded with metal threads and coloured silks. Waistcoats were an important part of the male wardrobe in the eighteenth century. They were typically made from fine fabrics and were sometimes, like this waistcoat and its inspiration, woven to shape, and finished with decorative buttons.[3]

Westwood has followed the basic cut of the original but has softened the neckline with a step at the centre front. She has done away with the sleeves and cut the armholes quite high to show off the shoulders. The fabric of the waistcoat, which closely copies the naturalistic floral pattern of the original, has been sensitively matched across the waistcoat fronts to maintain the movement and symmetry of the design.

The cut is still uncompromisingly masculine, but Romilly McAlpine found its tightness sexy, as it revealed the shape of the body underneath. Whereas the original would have been worn with a shirt, she wore it on its own or with an unbuttoned jacket.

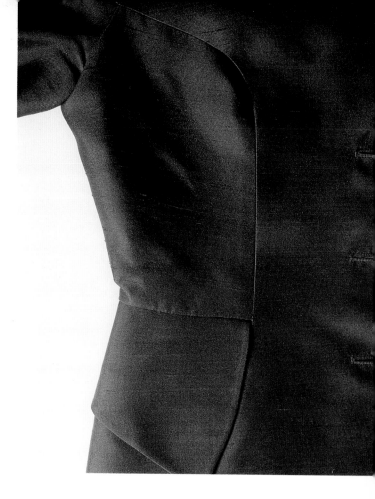

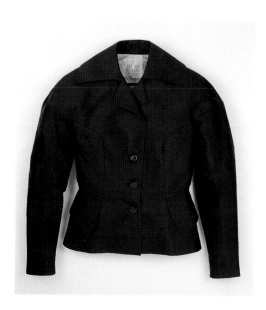

Wheat Jacket

Les Femmes ne connaissent pas toute leur coquetterie, Spring/Summer 1996
Shantung silk, lined with acetate

The softly padded, rounded shoulders and feminine silhouette of this jacket reflect
Westwood's interest in the elegant styles of the 1950s. The seams and details of the
jacket form a series of curves emphasising the swell of the breasts, the neat line of the
waist and the fullness of the hips. At the back, an inverted pleat fans out from the
waist, drawing attention to the bottom. Bias-cut side panels ensure a smooth close fit.
The jacket celebrates the mature female form and suggests a woman at ease with her
body and sexuality.

 Westwood became interested in the designers of the 1950s, particularly Christian Dior
and Cristobal Balenciaga, in the early 1990s when, in reaction to the current trend for
casual wear, she was experimenting with more sophisticated ways of cutting. 'I had not
realised how anarchical Dior was, what a wonderful urban elegance he created. So much
of his work revolved around making clothes look like bows. And that was not a matter
of detail, it was always a matter of cut, of employing a technique of which you are master.
I am into elegance now. I think, in this tasteless world, elegance can be subversive'.[4]

 By linking her working methods to those of the great designers of the past, Westwood
elevated her own status and set herself in the context of the couturiers. Today she
presents herself as a designer who is an intellectual and an artist-craftsman. The past
has been a rich sourcebook for her, stimulating her visually and intellectually, informing
her technique and provoking her to experiment. She continues to explore and articulate
her ideas through her clothes, bringing to the present a past of her own imagining.

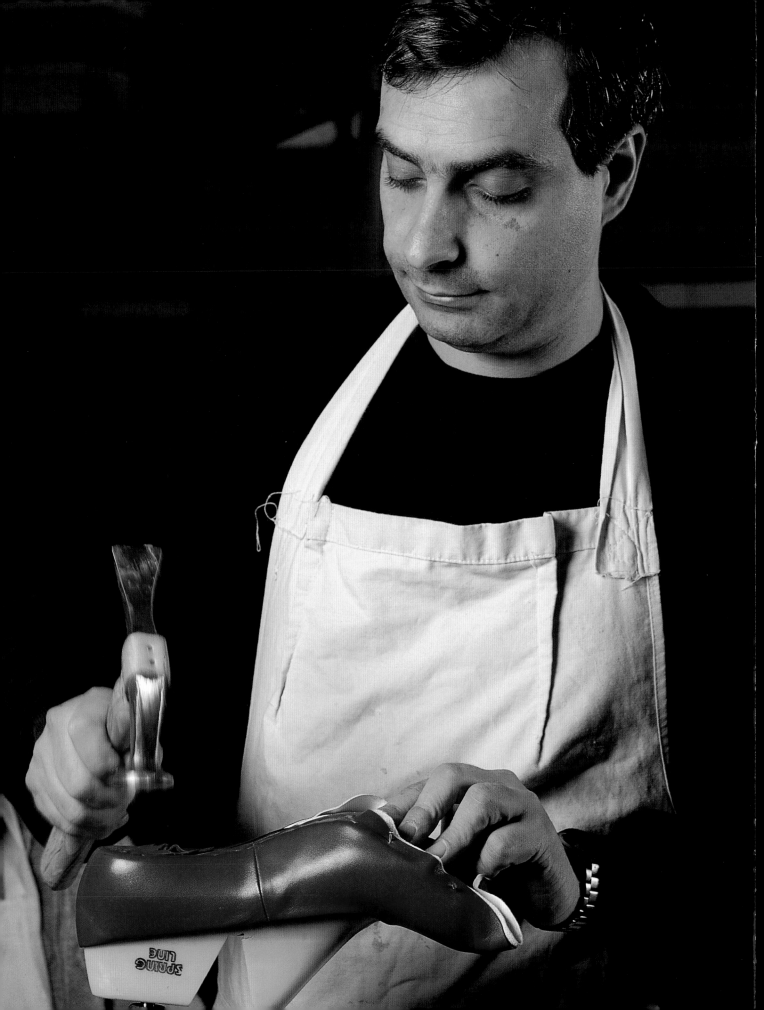

John Amathus
Shoemaker
on the Amathus Shoe Factory in Bow

It starts off with a piece of paper. We are sent a drawing with an indication of which last to mould the shoe on. We then draw the pattern onto the wooden last, take the dimensions, and transfer them onto paper. We cut the leather from these paper patterns and give it to the machinist. We then fit it once more to the last, make any final adjustments, then finish the shoe and send it back to Vivienne. They may ask for alterations, but if they approve, we simply make the shoes in the required materials. Most of the dyed leather comes from Italy, though we also get material from India, China, Brazil and the UK.

We started making shoes for Vivienne Westwood about fourteen years ago. The first shoes we produced for her were the Rocking Horse Ballerina and the Rocking Horse Boot. We're still making them, in fact. Then came the elevated shoe around 1990. Vivienne asked for a shoe with a hidden platform. Hence the two seams: the platform is not stuck on but is actually covered, built into the shoe itself. They were very popular in the nineties, and from there we went on to the super-elevated shoe, even higher than the ones that Naomi Campbell wore in 1993. And we've done all kinds of weird and wonderful things in between. At the moment we're working on a toe shoe.

I learned the trade of shoemaking from my father, who came to Britain from Cyprus in 1956. There are four of us who work here, including me and my father. Some of the newer workers have studied at the Cordwainers College, but many of us, though it's not so common now, were apprenticed to the trade. We watched and we learned. It's a dying craft. A lot of the work has now been overtaken by machines, but there are still shoes such as Vivienne's that cannot be produced mechanically and have to be made by hand.

Kerry Donovan
Former Studio Manager

on the Westwood Studios in Battersea

Initially Vivienne Westwood or Andreas Kronthaler will give the pattern cutters an idea of what they're looking for. Then Vivienne and Andreas will start with a first pattern, which we make up in calico or, if necessary, an alternative fabric, depending on what the end result is going to be. From there, the garment will be looked at on the stand and will go into a fitting. It then goes back and forth between Vivienne and the pattern cutters and us in the studio, always evolving and developing until Vivienne is happy with the design. We then make it up in the correct sampling fabric and, depending on the time limit and the style, send it on to Italy to be repeated for the Italian collections.

Sometimes the process can be quite quick. Something will come out and work straight away. Other times it can take us a whole season, depending on the style. Sometimes a design will come through and be fine at the first or second fitting, but then something else won't be right and it will go back and forth right up to the deadline, until it works. If it doesn't work, the design doesn't end up in the collection.

We mainly do Gold Label here in London, but we do help out with the Anglomania, Red Label and Man collections. But our main function here is to build the Gold Label collection. We also do the showpieces and the one-offs, because it's not worth sending them to Italy to be repeated. The special orders are also based here in Battersea in the other building.

Vivienne Westwood: the collections

PIRATE
Olympia, London
March 1981 (Autumn/Winter 1981)
Asymmetrical T-shirts, petti-drawers, pirate shirts, breeches, baggy-round-the-ankle flat heel boots. Ringlets and gold teeth.

SAVAGE
Olympia, London
October 1981 (Spring/Summer 1982)
Mixing historical garments with ethnic. Body paint, mud plastered into hair, oversized hats.

BUFFALO
Olympia, London
Angelina, Paris
March 1982 (Autumn/Winter 1982)
Brassieres over sweaters, sweatshirts with hoods worn with tailoring. Complete collection presented in muddy colours.

PUNKATURE
Cour du Louvre, Paris
October 1982 (Spring/Summer 1983)
Clothes that do not fit the body. A cut in which shapes based on rectangles struck a dynamic with the body. Jackets came up and sleeves fell down. More emphasis in this show on the asymmetrical, tube skirts and distressed fabrics.

WITCHES
Cour du Louvre, Paris
March 1983 (Autumn/Winter 1983)
Huge nylon mac worn over bodies covered in Keith Haring fluorescent hieroglyphics and trainers on the catwalk.

HYPNOS
Cour du Louvre, Paris
October 1983 (Spring/Summer 1984)
Fluorescent fabric worn with white.

CLINT EASTWOOD
Cour du Louvre, Paris
March 1984 (Autumn/Winter 1984)
Fashion garments smothered in company logos.

MINI CRINI
Cour du Louvre, Paris
Limelight, New York
October 1984 (Spring/Summer 1985)
A change of direction with a return to traditional fit. The emphasis was placed on the hip in the hope of killing the big shoulder. Crini, puff ball skirt, giant polka dot print and platform shoes.

HARRIS TWEED
Olympia, London
March 1987 (Autumn/Winter 1987)
Fine knitwear, twinsets and pearls for men as well as women, Rocking Horse platform shoes. Reintroduction of Harris Tweed and black velvet into fashion. Statue of Liberty corset.

PAGAN I
Olympia, London
October 1987 (Spring/Summer 1988)
Greek drapery worn with tailoring.

TIME MACHINE
Olympia, London
March 1988 (Autumn/Winter 1988)
Knockout skirt. Long skirts, slashed to the crutch at centre front. 'Armour' jackets.

CIVILIZADE
Olympia, London
October 1988 (Spring/Summer 1989)
Sweatshirts and track suits quartered into different colours as in heraldry.

VOYAGE TO CYTHERA
Olympia, London
March 1989 (Autumn/Winter 1989)
Jackets and shirts worn without skirts. 'Principal Boy' look. Harlequin.

PAGAN V
Olympia, London
October 1989 (Spring/Summer 1990)
City shirts and matching pyjama trousers as smart summer wear for men.

PORTRAIT
I.O.D., Pall Mall, London
March 1990 (Autumn/Winter 1990)
Old Master paintings on silk or fine wool combined with as many different fabrics as possible – fake fur, velvet, tweed, city stripe cotton, tartan – to create a feeling of richness. Gold foil printing with rococo design (Boulle).

CUT & SLASH (menswear)
Villa de Gamberaia
July 1990 (Spring/Summer 1991)
No shoulder pads or structure to close fitting tailoring, slashed and frayed fabric, especially denim.

CUT, SLASH & PULL
I.O.D., Pall Mall, London
October 1990 (Spring/Summer 1991)
All skirts worn at an elegant lower calf length. Cut and Slash plus giant circular shapes treated as Greek chiton.

DRESSING UP
Azzedine Alaïa, Paris
March 1991 (Autumn/Winter 1991)
A culmination of past collections. The opposite of dressing down. An eclecticism which includes historical and primitive clothes.

SALON
Azzedine Alaïa, Paris
October 1991 (Spring/Summer 1992)
First influence of twentieth-century couture, especially Dior.

ALWAYS ON CAMERA
Le Monde de l'art, Paris
March 1992 (Autumn/Winter 1992)
Continuing influence of twentieth-century couture and Hollywood. Directors and managers dressed their stars in a parody of French couture. Photographic discharge print of Marlene Dietrich (especially on denim). Make-up: Marlene's eyebrows.

GRAND HOTEL
Le Grand Hôtel, Paris
October 1992 (Spring/Summer 1993)
Strong development of cut results in an original representation of the fifties cut. Long circle skirts, off-the-shoulder necklines. Superior elevated court shoes (10" heels).

ANGLOMANIA
Le Cercle républicain, Paris
March 1993 (Autumn/Winter 1993)
This term describes the French passion for all things English – literature, language, cloth, even food – at the end of the 1800s. An eclectic mixture of English styles from Elizabeth I to 1950s couture.

CAFÉ SOCIETY
Le Grand Hôtel, Paris
October 1993 (Spring/Summer 1994)
Inspired by the period between 1890 to 1910, especially the French style of that time. The collection has its roots in the clothes of Worth – the first French couture house, famous for its opulence and technical brilliance. Emphasis placed on the bustle and bust. Jackets worn as shirts, with rich print (Redouté roses).

ON LIBERTY
Carrousel du Louvre, Paris
March 1994 (Autumn/Winter 1994)
Liberty prints dating back 100 years. Printed on pile, needlecord and quilted georgette. Large tailoring section. New silhouette incorporating a cushion at the back and an upward slope of the shoulder: the new Power Dressing. Handmade knitwear in wool and lurex.

EROTIC ZONES
Carrousel du Louvre, Paris
October 1994 (Spring/Summer 1995)
Tailored trouser suits inspired by Otto Dix from his painting of Krall. Fitted jackets with high-waisted trousers. Vivid Liberty prints in paisley and daisy. Textured knitwear dresses and suits in bright colours. The cage replaces the cushion.

VIVE LA COCOTTE
Carrousel du Louvre, Paris
March 1995 (Autumn/Winter 1995)
The inspiration, La Cocotte, is Ninon de l'Enclos. Tailoring in cashmere, loden, alpaca and tweed. Fil coupé and chenille knitwear.

LES FEMMES
Salle de l'opéra, Grand Hôtel, Paris
October 1995 (Spring/Summer 1996)
La Rochefoucauld wrote: 'Les femmes ne connaissent pas toute leur coquetterie' ('Women do not understand the complete extent of their coquettishness'). Excess stripped away to show clothes a woman could wear every day. Tailored suits and coat dresses, nautical knits, back swag jackets in shantung.

VIVIENNE WESTWOOD MAN
Ex Stabilimento Motta, Milan
January 1996 (Autumn/Winter 1996)
The first menswear show with new production. Begins with a nightdress followed by a large tailoring section, knitwear, leather, beaded jackets and an evening wear section.

STORM IN A TEACUP
Carrousel du Louvre, Paris
March 1996 (Autumn/Winter 1996)
'Mi'lady maintains her equilibrium though she feels that gale-force winds may blow her clothes away. Drama becomes a mere storm in a teacup when one's self-perception is intact'. Asymmetric cut. Most Credited Designer at 'Vénus de la Mode' awards.

MAN
Ex Stabilimento Motta, Milan
July 1996 (Spring/Summer 1997)
'My man is a humanist who values the idea of personal liberty above all else. His passionate curiosity at the past wonders of human achievement frame his appreciation of the world of adventure in which he finds himself'.

VIVE LA BAGATELLE
Carrousel du Louvre, Paris
October 1996 (Spring/Summer 1997)
'It's about flirting . . . a trifle, a nothing, a ribbon; a bow tied prettily and easily undone'. Tailoring and flou. Military tailoring adopted for the practicalities of country life and business in the eighteenth-century. Classic, baroque and asymmetrical.

MAN
Teatro Nuovo, Milan
January 1997 (Autumn/Winter 1997)
The influence of the Italian Renaissance. A blousy volume in the shirts, high and formal collars. Voluminous tailored jackets with slim trousers. Tudor architecture infiltrates the seaming and pocket flaps. Black, deep burgundy.

RED LABEL 'TO ROSIE'
The Dorchester, London
February 1997 (Autumn/Winter 1997)
'Are you really being rebellious by copying your friends? . . . Just because you're chasing about a bit doesn't give you the right to insult your mother'. Earthy colours of the English countryside, browns and muddy greens, grey, anthracite, black, camel and dark red.

FIVE CENTURIES AGO
Le Lido, Paris
March 1997 (Autumn/Winter 1997)
A move from the influence of later centuries back to the sixteenth century, which Westwood had always found daunting. Female dress in sixteenth-century portraits, skirts of heavy fabrics laid over cone-shaped wooden frames, a carapace of a bodice, hats of architectural geometry which hid the hair and sleeves so long and full that the lady joined her hands in front so as to carry their weight. A translation to modern times.

MAN
Tenda Palestro, Giardini Pubblici, Milan
July 1997 (Spring/Summer 1998)
A lean, fitted jacket with generous lapels, a jacket along the natural shoulder line tailored to stand away from the body, an 18th-century frock coat, a jacket from ladies tailoring of the fifties to achieve the comfort of a tight-fitting cardigan. Shirts cut close to the body with generous collars and cuffs.

RED LABEL 'THE ENGLISH GIRL ABROAD'
Shakespeare's Globe, London
September 1997 (Spring/Summer 1998)
The well-bred English girl: a 'natural' with rosy skin and a healthy country physique. Charm is second nature to her. This girl is the key to what makes all young English women look so different. Classless girls of independent spirit, spontaneous and artless.

TIED TO THE MAST
Hôtel de Crillon, Paris
October 1997 (Spring/Summer 1998)
Sea-faring fashions. Sixteenth-century clothes edged with a contrasting frame. Mitering instead of appliqué to make stripes turn corners and frame edges. A slightly higher waist and a small torso, helped by a subtle paring away of the ratio between sleeves and bodice and the juxtaposition of bell or cone-shaped skirts.

MAN
Circolo della Stampa, Milan
January 1998 (Autumn/Winter 1998)
Check shirt, striped jacket, V-neck sweaters, and a jacket inspired by women's couture with a nipped-in waist. A melodramatic black mac with a batwing storm collar and a great black cartwheel of a hat. Ballooning trousers cropped to mid-calf (Comedy) or long (Tragedy). Giant pomegranate design.

RED LABEL
Café de Paris, London
February 1998 (Autumn/Winter 1998)
'The Red Label woman is not a girl, she is a young lady. She knows the power of coquetry. She dresses to be noticed, to enjoy life and to pull her man. She wants to enjoy herself and be enjoyed'. Melton with raw cut edges, sparkling lurex, printed flannel or velvet stretch.

DRESSED TO SCALE
Hôtel de Crillon, Paris
March 1998 (Autumn/Winter 1998)
De-emphasise a woman's ribcage by making all the detail in relation to the total design as large as possible? Collar, cuffs, pockets, plackets, oval buttons enlarged to 2.5" diameter. Black, a creamy greenish white, scarlet and a warm vermilion, dirty mauve.

MAN
Circolo della Stampa, Milan
June 1998 (Spring/Summer 1999)
The silhouette emphasises the proportions of the male body. Narrow waisted jackets. Jackets cut with a contrast from the waist. Big buttons and narrow collars. Giant dots and overlapping squares complement the stripes and ginghams.

RED LABEL
The Tabernacle, London
September 1998 (Spring/Summer 1999)
Inspired by tropical flowers and colours: fuchsia, green, purple. Dress styles are draped and fluid with wrap dresses for the evening.

LA BELLE HÉLÈNE
La Bourse, Paris
October 1998 (Spring/Summer 1999)
Inspired by Rubens's portrait of his second wife 'Hélène Fourment putting on her glove'. Stretch wool, cotton and silk suiting mould the body; evening fabrics include lace mounted on wool or organza. Prints inspired by Matisse. Ballerina shoes, flat sandals and solid plexiglass hairpieces.

MAN
Circolo della Stampa, Milan
January 1999 (Autumn/Winter 1999)
Argyll knitwear with matching bottoms, lurex leopard print. Tartan features in kilts, jackets and trousers in green and brown. Black stretch wool and duchess satin for evening, mixed with metal knit vests. Swarovski crystal features in trousers. Silhouettes reminiscent of Greek statues.

RED LABEL
Celeste Bartos Forum, New York Public Library
February 1999 (Autumn/Winter 1999)
'I started off in London and arrived via Scotland, Russia, Peru, Africa, mixing as I went: attitudes, prints, blankets, souvenirs'. Clashing colours. Natural fabrics rough to touch and look at. Great gear for tough dolls you play with, then worship.

GOLD LABEL
Vivienne Westwood Showroom, Paris
March 1999 (Autumn/Winter 1999)
Wool and stretch jersey with 'fingers' of fabric criss-crossing the bodice. Leather and sheepskin. Browns, dark greens, greys and blacks, with flashes of colour. Argyll, windowpane check, blocks of colour. Experimentation with diamond shapes.

References

Epigraphs

p.13 Paul Burston, 'Westwood', *Attitude*, March 1995.

p.25 Sarah Mower, 'British Style', *Vogue*, June 1991.

p.65 Roger Tredre, 'Westwood holds court among the Soho tea set', *The Independent*, 14 October 1991.

p.70 Phillis Cunnington & Alan Mansfield, *English Costume for Sports and Outdoor Recreation*, London 1978, p. 204.

p.71 Lowri Turner, 'Outrageous Vivienne stuns Paris with best of British', *Evening Standard*, 17 March 1993.

p.72 Martyn Harris, 'New Horizons with Gary and Proust', *Daily Telegraph*, 11 May 1994.

p. 73 Simon Garfield, 'The faith that launched a thousand zips', *The Guardian*, 15 August 1998.

Introduction

1 John Fairchild, *Chic Savages*, London 1989, p. 34.

2 Catherine McDermott, 'Vivienne Westwood ten years on', *i-D* (UK), February 1986.

Collecting Westwood

1 Circle jacket and mini pencil skirt, *Voyage to Cythera*, A/W 1989.

2 Portrait jacket and criniscule skirt, *Dressing Up*, A/W 1991.

3 Long Jim jacket and long side-slit skirt, *Dressing Up*, A/W 1991.

4 Mackintosh raincoat, *Dressing Up*, A/W 1991.

5 Arresting skirt, *Anglomania*, A/W 1991.

6 Krall jacket, waistcoat and trousers, *Storm in a Teacup*, A/W 1991.

7 Grand Midnight Experience skirt and draped corset, *Café Society*, S/S 1994.

8 Diamond-encrusted codpiece corset, *Dressing Up*, A/W 1991.

9 Super double-breasted coat, waistcoat and trousers in Ancient Bruce of Kinnaird tartan, *Anglomania*, A/W 1993.

10 Shredded tulle skirt, boa and Boulle tulle SOL corset, *Salon*, S/S 1992.

Making Westwood

1 Angela McRobbie, *British Fashion Design: Rag Trade or Image Industry?*, London 1998, pp. 109-11.

2 The McAndreas tartan is a variation of the Ancient MacDonald, introducing new colours to the basic design, or sett. There are two variations; this one, a Special Turquoise Anderson, was introduced in 1993.

3 Natalie Rothstein, *Silk Designs of the Eighteenth Century*, London 1990, plates 238 & 239, p. 230. This waistcoat was copied from a man's sleeved waistcoat now in the Costume Institute at the Metropolitan Museum of Art in New York. The original design by Garthwaite is in the Victoria & Albert Museum, London (5985.13).

4 Brenda Polan, 'Master Strokes', *Tatler*, August 1992.

Further reading

Books

Baudot, François, *Fashion: The 20th Century*, New York 1999

Buxbaum, Gerda, ed., *Icons of Fashion: The 20th Century*, New York 1999

De La Haye, Amy, ed., *The Cutting Edge: British Fashion 1947-1997*, London 1997

De La Haye, Amy & V. Mendes, *20th Century Fashion*, London 1999

Krell, Gene, *Vivienne Westwood*, London 1997

Martin, Richard, *The Ceaseless Century: 300 Years of 18th Century*, New York 1998

McDermott, Catherine, *The Design Museum Book of 20th-Century Design*, London 1998

McDermott, Catherine, *Vivienne Westwood*, London 1999

McDowell, Colin & Frederick Muller, *McDowell's Directory of 20th-Century Fashion*, London 1984

Mendes V. & C. Wilcox, *Modern Fashion in Detail*, London 1991

Mulvagh, Jane, *Vivienne Westwood: An Unfashionable Life*, London 1998

Musée de la Mode et du Costume, *Le Monde selon ses créateurs*, Paris 1991

National Portrait Gallery, *Faces of the Century*, London 1999

Rothstein, Natalie, ed., *400 Years of Fashion*, London 1984

Simon, Marie, *Fashion in Art*, London 1995

Stopler, Paul, *I Groaned With Pain*, London 1996

Tucker, Andrew, *The London Fashion Book*, New York 1998

Vermorel, Fred, *Fashion and Perversity: A Life of Vivienne Westwood*, London 1996

Wilson, Elizabeth, *Adorned in Dreams: Fashion & Modernity*, Berkeley 1987

York, Peter, *Style Wars*, London 1980

Periodicals

Alderson, Maggie, 'Mother of Invention', *Elle* (USA), May 1991

Alford, Lucinda, 'Westwood Ho!', *The Observer Magazine*, 7 February 1993

Armstrong, Lisa, 'Fashion Diary: Designs on Fashion', *The Times*, 23 November 1998

Barber, Lynn, 'How Vivienne Westwood took the fun out of frocks', *The Independent on Sunday*, 18 February 1990

Baudot, François, 'Vivienne Westwood: notre dame des punks a bien changé', *Elle* (France), 25 April 1994

Bayley, Stephen, 'See Anything You Like?', *Observer Review*, 20 September 1998

Bennett, Oliver, 'Westwood World', *The Independent*, 18 May 1997

Brampton, Sally, 'The Prime of Miss Vivienne Westwood', *Elle* (UK), September 1988

Casciani, Stefano, R. Molho & M. Romanelli, 'Form Follows Fashion', *Arbitare*, April 1997

Costa, Emma, 'All the Bad Boys And Girls', *Donna*, March 1993

Croan, Stephanie, 'The World Without End', *The Sunday Times Magazine*, 6 September 1987

Fairley, Josephine, 'Viva Vivienne!', *Clothes Show*, January 1991

Falconer, Karen, 'Building a New Vivienne Westwood Empire', *Fashion Weekly*, 25 April 1991

Frankel, Susannah, 'Tweed Coat No Knickers', *Guardian Weekend*, 22 February 1997

Franklin, Caryn, 'Rule Britannia: Viv Rules OK', *i-D* (UK), March 1987

Fraser, Honor, 'An English Woman of Real Style and Originality', *Literary Review*, September 1998

Glenville, Tony, 'Vive Vivienne', *Drapers Record*, 15 January 1994

Golding, Paul, 'Vivienne Westwood and the Empress's Clothes', *Evening Standard*, 16 October 1991

Harlow, John & Patricia Nicol, 'Westwood Scorns Arrogant English', *The Sunday Times*, 24 January 1999

Hennessy, Val, 'Portrait of a Bag Lady', *The Mail on Sunday Magazine*, 21 October 1990

Jobey, Liz, 'Salon Fever', *The Independent on Sunday*, 5 January 1992

Jobey, Liz, 'Vivienne Westwood', *Vogue* (UK), August 1987

Lott, Tim, 'My Decade: Vivienne Westwood', *The Sunday Correspondent Magazine*, 19 November 1989

Lutyens, Dominic, 'Fashion's Pearly Queen', *Independent on Sunday*, 8 November 1998

MacDonald, Marianne, 'Full Mental Strait Jacket: More of an Intellectual than a Designer', *Observer*, 28 September 1997

McDermott, Catherine, 'Skirting Sedition', *Creative Review*, June 1986

Menkes, Susan, 'We are not amused', *Illustrated London News*, Winter 1989

Mower, Sarah, 'The Triumphal Reign of Queen Vivienne', *The Observer Magazine*, 25 October 1987

Mulvagh, Jane, 'Method In Her Madness', *Illustrated London News*, Spring 1991

Perint Palmer, Gladys, 'Vivienne Westwood habille les célébrités', *L'Officiel*, August 1994

Polan, Brenda, 'Joie de Vivienne', *The Independent on Sunday*, 7 October 1990

Polan, Brenda, 'Queen of Inspiration', *Financial Times*, 28/29 November 1992

Quick, Harriet, 'Westwood retro', *Elle* (UK), March 1994

Quick, Harriet, 'Go Westwood Young Man', *The Face*, September 1996

Roberts, Yvonne, 'Queen Viv', *Harpers & Queen*, October 1993

Robson, David, 'Celebrating Life with the Profane and Sacred', *Daily Express*, 21 November 1998

Summer, Beth, 'What Next?', *i-D* (UK), May 1991

Tredre, Roger, 'Simply Men in Mind', *The Independent*, 12 July 1990

Watson, Shane, 'My Brilliant Career: Vivienne Westwood', *Elle* (UK), November 1995

Watt, Judith, 'By Design', *For Him*, Autumn 1989

Westwood, Vivienne, 'Pursuing an image without taste', *The Independent*, 9 September 1989

Westwood, Vivienne, 'A retrospective of designs from 1972-1987', *The Face*, May 1987